EUGENE BURNAND

EUGENE BURNAND

In Search of the Swiss Artist
(1850–1921)

Shirley Darlington

UNIFORM

Published by Uniform
An imprint of Unicorn Publishing Group
101 Wardour Street, London W1F 0UG

www.unicornpublishing.org

A catalogue record for this book is available from
the British Library

5 4 3 2 1

ISBN 978-1-910500-50-7

Cover design Unicorn Publishing Group
Typeset by Vivian@Bookscribe
Printed and bound in India

DEDICATION

For Jonathan and Miriam Darlington,
and all my wonderful friends

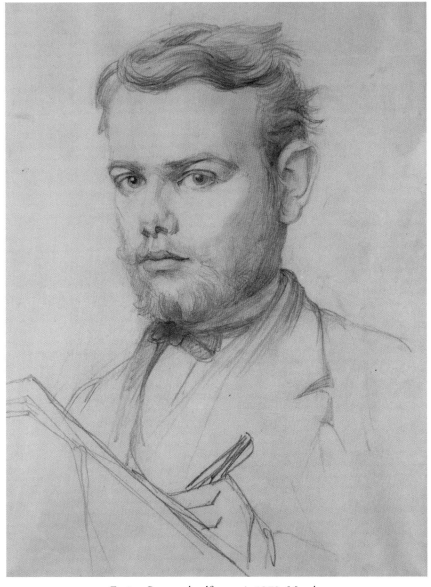

Eugène Burnand, self portrait 1872, Moudon

ACKNOWLEDGEMENTS

I would like to thank the following:

❦

Musée National de la Légion d'honneur et des ordres de chevalerie, Paris, for their kind permission to reproduce pastel portraits of participants in the First World War by the artist Eugène Burnand, held in their collection, and especially for the helpful response of the Curator, Anne de Chefdebien and her colleague Patrice Grelet, collections manager. (Photography, Fabrice Gousset)

❦

Musée Eugène Burnand, Moudon, Vaud, Switzerland for permission to reproduce the art works of Eugène Burnand kept there, and the invaluable help given by Carole Saint-Loup, Directrice, Moudon Tourisme.

❦

Hotel Victoria, Glion-sur-Montreux, Vaud for permission to reproduce their painting by Eugène Burnand, *Le Lac Léman au Premier Printemps*.

❦

Céline Sanchez Bayarri, for kind permission to reprint her photograph of her great-grandfather Fernand Ruan, one of Burnand's subjects, and for sharing her story

❦

Kay Blackburn, tutor in history of art, Lewes WEA, for taking an interest and supporting me in this project

❖

Doug Jenkinson for photography, computer skills, his wonderful website, ferrying me about, encouraging me to write this story, and his cheerful companionship

❖

Jonathan Darlington for practical help; Miriam Darlington, Hannah Hyam, Janet Theakston, Robin Richardson, and Elizabeth Whitehouse for reading drafts and making helpful comments

❖

Professor Philippe Kaenel of Lausanne University, for patiently answering my questions

❖

Last but not least, Ian Strathcarron and Ryan Gearing at Unicorn Publishing Group, for having faith in me and in this book, and all the team who made it possible.

AUTHOR'S PREFACE

Out of the blue, one summer morning a few years ago, a message appeared in my inbox: "Doug Jenkinson has sent you a message."

Did I know this person? Being circumspect, I did not reply. Then again, a few days later, more insistently: "Doug Jenkinson is trying to contact you." The name began to sound vaguely familiar. So I opened *Friends Reunited*, a forerunner of Facebook, and there was the message: "You probably won't remember me, but…." We had been in the same class at primary school, though as a rather shy and well brought up young lady, I had failed to notice the boy who had once sat next to me.

Now a retired family doctor, this former admirer had sought me out, and I could not fail to be flattered. Careers and marriages over, with grown up children, we exchanged our life stories and agreed to meet up in Cumbria, a favourite haunt of both. We talked non-stop, and kept up an email correspondence over the ensuing months and years. We discovered a mutual interest in art, and travel, amongst other things. Doug made me aware of his intention to find out about a famous ancestor, Eugène Burnand, a Swiss painter to whom he thought he was distantly related, and I offered help with translations from the French.

What happened next, a journey of discovery to trace the Swiss artist and his wonderful paintings, is the subject of this book. I could never have dreamed of the treasures awaiting me. This quest led us to Paris, where the artist's stunning First World War portraits are displayed; to Moudon, near Lausanne in Switzerland, the birthplace of Eugène Burnand, which has

a whole museum dedicated to his art; to his family home in a tiny Swiss village; to Assisi where he painted the stories of the life of St. Francis; and who knows where next?

The most famous Swiss artist of his day, Burnand was in danger of being forgotten. I hope this book will help secure a better understanding of the work of an artist whose originality and quality deserve more recognition and a wider appreciation. Its special focus is on the amazingly sensitive and moving pastel portraits of soldiers from all nationalities on the allied side in the First World War, which have special relevance in the centenary years of that war. Most of all, I hope it will interest readers with a love of art, and particularly those wanting to know more about all those who fought in the Great War, 1914–18.

My thanks are due to Doug, whose sense of adventure and commitment to exploring inspired the project. His friendship, photographic skills, shared knowledge and encouragement have made this book possible.

Shirley Darlington
Lewes, October 2015

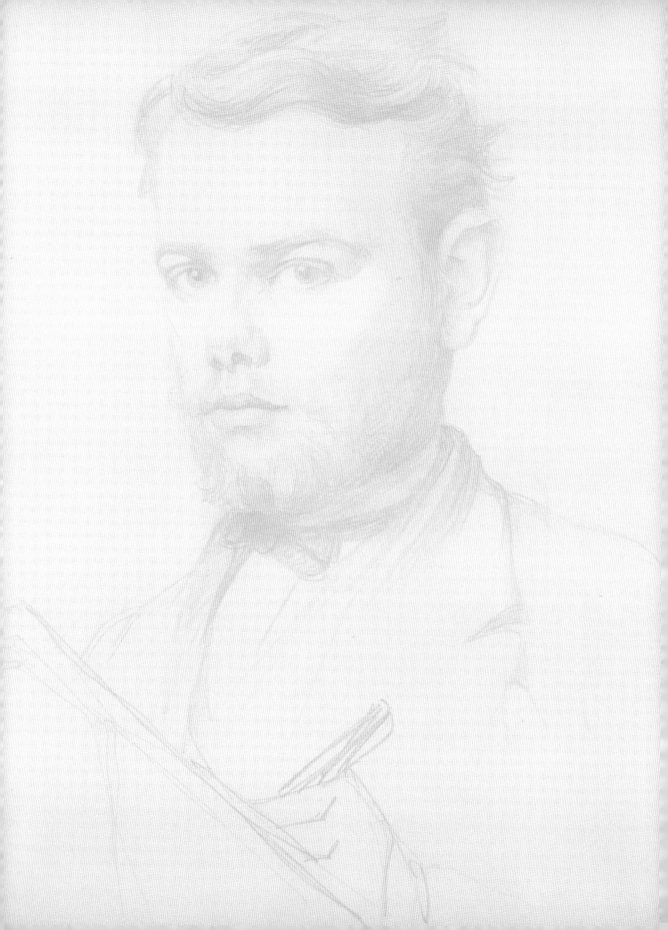

PART ONE

DISCOVERIES

"Come and look at this – I've something to show you!" said my friend Doug, and I followed him to his motor home. He had called in briefly on his way to Devon. I climbed in up the steps (the motor home is his pride and joy – rather like a snail with its shell) and I was offered a cup of coffee, and a book in French, which he reached down from an overhead locker. It was quite large, with a shiny cover, and a portrait of a bearded artist on the front, conventionally dressed in an elegant grey suit with a white shirt and dark cravat. Around him were grouped portraits of soldiers, and the book's title was *Portraits de La Grande Guerre*.

As I opened the book and started to turn the pages, I was almost speechless with amazement. These pastel portraits were so beautiful, I gasped as I looked at them. Each one was of a soldier, or pastor, or nurse, who had served on the allied side in the First World War. They were so faithfully depicted, head and shoulders only, with a few identifying marks on their uniforms. Their expressions were often solemn, some looked frightened, especially the young boys, and many showed the ravages of conflict in the premature lines on their faces.

I learned that the artist, who was Swiss, and a distant relative of my friend Doug, had in 1914 on the outbreak of hostilities been confined to his country family home in Switzerland for most of the war. But in 1915, towards the end of his life, he had the idea of painting a series of portraits of people of all the many different nationalities who served on the Allied side in the Great War of 1914–18.

His mission was to make a record of all who had contributed, bringing out their psychological characteristics and personalities. He wanted to show that the representative types he portrayed came from many different corners of the globe, from the former colonies of France and England, as well as the different regions of France, the United Kingdom, Australia,

New Zealand, Canada, and North America. They came from all ranks, the lowliest foot soldier or trench digger to the highest General or Admiral, and from each branch of the services, the army, navy and even one airman. There were noble Sikhs in turbans, dignified North Africans, and several black riflemen from far flung French colonies. They were done in full colour and they glowed out of the pages.

I had to learn more about this artist, who I had never heard of before. His name was Eugène Burnand.

<div align="center">❦❦❦❦❦</div>

My next encounter with the artist, and my friend Doug, came in the form of another, much larger book. This one was delivered to my door in Sussex in a huge brown package. It was obviously very heavy, and very old, acquired from a French dealer. As it was carefully taken out of its wrappings it emerged almost pristine, though published in Paris in 1922. It contained the same pastel portraits, one to a page, each one an engraving, photogravure, mostly in colour but some reproduced in black and white only.

Each portrait was accompanied by descriptive text in French. I discovered to my amazement the book had a handwritten foreword by Marshal Foch, the famous general, then commander of the Allied troops. It also contained a lengthy and appreciative preface by Louis Gillet, a renowned art critic of the time.

The book, with its navy blue hard cover embossed with gold, was almost too heavy for me to lift, so I carried it to my table and started looking and reading, with mounting excitement. Doug explained that he planned to make a website about the artist, since although Eugène Burnand had been famous in his home country of Switzerland and in his adopted and

much-loved second home France, there appeared to be little or no information about him in England. The intention was to put his work on the website, with the accompanying texts. I realised someone was needed to translate the rather flowery and literary texts accompanying each picture, so I tentatively offered to help.

"Would you like me to have a go at this, to see what I can do?"

"Well yes, that would be wonderful", was the reply.

And so started a fruitful collaboration, and very many hours of painstaking work. Six months later the translations were complete, though of course I would wake in the middle of the night thinking of a better word or phrase to resolve a difficult puzzle, or to bring to life the writer's descriptions. We wondered about the writer, who, it turned out was Eugène's nephew and godson Robert, who had served as a captain in the French army. I had to learn an awful lot of abstruse military vocabulary, and I never realised there were so many different kinds of helmet, which emerged to be an important distinguishing mark.

Spending so much time gazing at these individual portraits, and reading about their subjects, I came to love these men and women. They became real to me: I empathised with their characters, their hardships, their sufferings, their bravery, and wanted to know their fate. They had been painted "knee to knee" by Burnand in his studio, between 1917 and 1921, either in Paris, or Montpellier or Marseille. He sought out representative types, of all nationalities, got to know them, gained their confidence and somehow managed to capture their souls in his portraits. They are mostly named, and their rank and company noted. They are frozen in time, and given eternal significance by the artist. That Great War took place a hundred years ago, yet these portraits have the power to bring us face to

face with the real people caught up in it. And the quality of the work, the sympathy and humanity of the artist, give more insight and depth to their characters than a photograph could ever do.

<p style="text-align:center">❧⳽✴⳾☙</p>

This time the gift of a book arrived through the post unexpectedly. I opened the package, wondering who had sent it, and why, then I realised the beautifully marbled hard cover with soft leather binding and gold lettering was a biography of the artist. As I turned the pages a powerful scent of tobacco emerged: its one time owner must have been a pipe smoker.

The author was René Burnand, Eugène's son, a doctor and writer. It was published in 1926, a few years after the death of the artist, and was clearly a labour of love, containing verbatim quotations from Eugène Burnand's diaries, family history, accounts of his artistic development, his views on life and art, and an analysis of how his work was received. It was illustrated with many of the artist's own sketches and pictures, reproduced mostly in black and white, with a few in colour. It was of course written in French, so had to be read carefully and slowly.

Eugène Burnand was born in 1850 in Moudon, a small medieval town in the Canton of Vaud, Switzerland, to bourgeois well-educated Protestant parents. The rural countryside around the town, with its hillsides, farms and streams inspired the young Eugène to draw, and from his youth his vocation as an artist was clear. The family travelled to Italy while Eugène was still young, and he saw the beauties of Italian Renaissance art and architecture while still a boy. His schooling was mostly in the French-speaking part of Switzerland at primary level, with a term spent in Florence at the age of ten, then in the German-speaking part in Schaffhouse for his secondary education.

Later he studied architecture in Zurich, because his father wanted him to have a career which would ensure a livelihood. But his diaries record his conviction that his real vocation was that of an artist, and he managed to persuade his father that it was art he must follow, once he had completed his architectural diploma. His practical father insisted that he show his work to a respected Swiss artist for an opinion before supporting his wish to go and study fine art in Paris, and accordingly Eugène submitted examples of his drawings to Barthélemy Menn, who took him on as an art student in Geneva in 1871, and had a strong influence on his work. After a year or so he was then accepted into the Ecole des Beaux Arts in Paris, where he studied under the painter Léon Gérôme, and also travelled to Florence and Rome as part of his artistic training.

He was a classically trained artist, painting naturalistic scenes of rural life, animals, landscapes and portraits. He excelled in book and periodical illustration and exhibited widely, becoming a well-known and highly regarded artist in France and Switzerland in the late nineteenth and early twentieth centuries, winning prizes including a gold medal (First Class) at the Paris Salon. When his financial circumstances permitted, he turned to painting religious subjects in an unconventional Protestant way, for example a series of illustrations of the Parables, which portray the subjects as real men and women of the time, rather than in an archaic manner. He used his own friends and neighbours as models. This realism found him at odds with the modernist and more abstract schools of painting prevalent in Europe at that time, and some critics dismissed him as old fashioned, but he stuck to his principles of painting what he saw in an accessible manner.

He married Julia Girardet, the daughter of a fellow artist and engraver, and moved to Versailles. The Girardet family were famous artists and

RIGHT: *"Taureau dans les Alpes", Bull in the Alps, 1884. Moudon*

engravers, and Eugène learnt the technique of engraving from them. His family grew and he travelled with them, settling in Provence at Fontfroide near Montpellier, and always spending summer in the family home in Sépey, a hamlet near Moudon. The family also spent some time living in Neuchâtel as he wanted his children to be close to their Swiss roots. He had an atelier, or studio workshop, at each of these homes, and as his fame grew had one in Paris too. He was always painting and drawing, it was his whole life, and he wished to record for posterity the rural way of life in his home country. He painted some huge canvases, the most famous of which was a terrific painting of a bull standing on the edge of a precipice in the Alps, bellowing into the valley. One can almost hear the echo roaring around the fabulous mountain landscape.

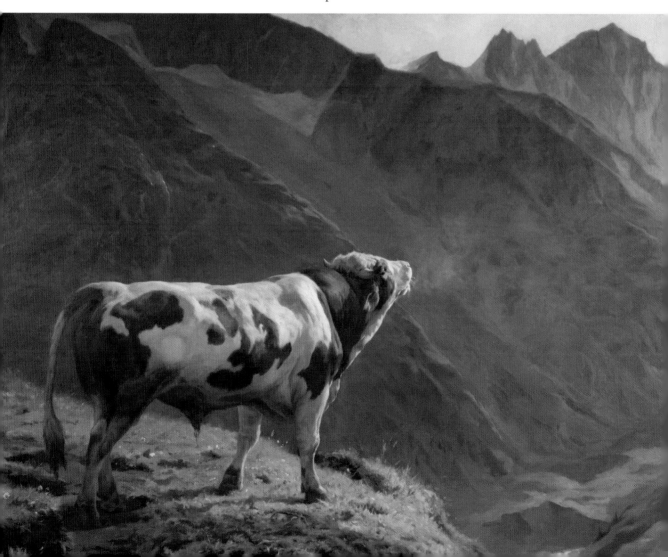

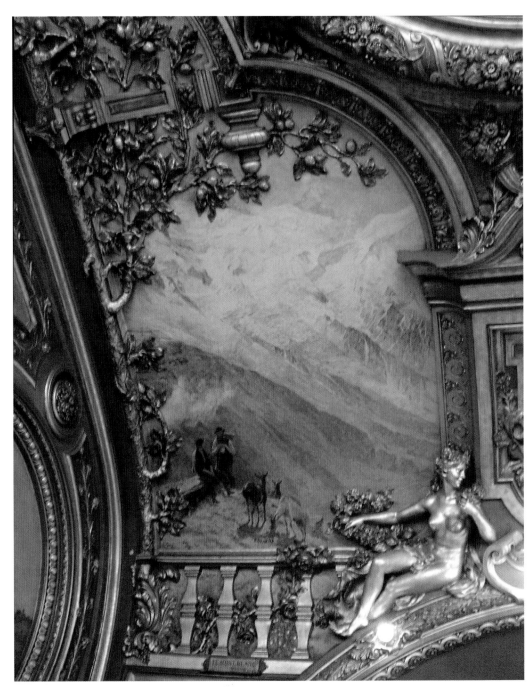

Mont Blanc vu de la Clergère (ceiling mural) "Le train bleu",
Gare de Lyon 1900

I learned from his biography that as an honoured member of the Société des Beaux Arts in Paris he was commissioned to oversee Switzerland's contribution to the great Paris exhibitions of 1889 and 1900, and painted a mural for the ceiling of the restaurant of the Gare de Lyon for the celebrations at the turn of the century. He was made a chevalier and an officer of the Légion d'honneur towards the end of his life, and was elected a member of the Institut des Beaux Arts, which pleased him greatly. And after his death, his fine series of one hundred and one First World War pastel portraits found a home in the Musée de la Légion d'honneur in Paris, given to the French nation by an American philanthropist. This was surely his crowning achievement.

A trip to Paris seemed indicated.

"You know", I remarked to Doug, I'd love to go to Paris to see the real thing."

"That can be arranged", he said.

So one chilly January morning we met up at St Pancras and took the Eurostar to the Gare du Nord. I was so excited, I arrived early at the station, and Doug, of course, being more laid back than me, was late. We boarded the train by the skin of our teeth. Then the métro to the restaurant, Le Train Bleu. Such *belle époque* magnificence, chandeliers, white starched tablecloths, and the amazing murals decorating the ceilings – I realised they were of all the destinations in Europe that the famous blue train had whisked travellers to, by renowned artists at the turn of the century. After a delicious lunch we walked round to admire the paintings, and found the one by Eugène Burnard – a magnificent depiction of Mont Blanc, with a small family and goats on a promontory in the foreground. I was in heaven.

Our next stop was the Musée de la Légion d'honneur, an imposing neo classical building next to the Musée d'Orsay. I found it rather stiff and intimidating, and it seemed to be staffed by former military men and women, who looked as though they would stand no nonsense. It was a free museum, so I suppose it had to be well guarded, as it is full of military medals and memorabilia. We finally found our way upstairs to the corridor linking two rooms, where the Burnand portraits are displayed facing each other in rows. The light is low, so I was a little disappointed that they could not be displayed to better advantage, but perhaps it is to protect the delicate pastels. They were larger than I expected, almost life size, head and shoulders only. I was thrilled to be able to see those portraits, which had become so familiar to me, at such close quarters. As we approached the pictures a guide was explaining them to a tour group of visitors, and I could tell that she was stressing (in French) how very honoured they were to have this important collection of portraits of those who had served in the First World War, from all corners of the globe, especially in the anniversary year of the beginning of that war.

As we left, feeling thoughtful, Doug purchased for me a modern version of the collection of portraits published by the museum, with a commentary by a military historian, which had been made especially to commemorate the centenary of the 1914–18 war. This book is also illustrated by contemporary photographs of the types of soldiers Burnand had portrayed, giving them extra significance.

We then moved on to the Musée d'Orsay, where all Doug's gadgets in his coat pocket nearly set off the alarm system and almost had him refused admission. The security man finally let him in with a sigh, acknowledging that he was probably no terrorist. I love the Musée d'Orsay, and enjoyed re-visiting old friends on the walls, particularly in the Impressionist and

Post-Impressionist rooms. But there was no sign of the painting we were seeking, Burnand's famous oil painting of the Disciples Peter and John running to the tomb on the morning of the Resurrection, which had been bought for the French state. Finally we admitted defeat and went to ask at the information desk where it was. "In store", was the answer. Somewhat weary and a little deflated we decided it was time to go home, and made our way back to the Gare du Nord, where we shared a beer in a rather unsalubrious corner before the Eurostar carried us back to London.

This experience was a special one, which brought me closer to the artist's work, but made me realise that though he was once held in such high regard, his best work was in danger of being forgotten. I think it made us both even more determined to do all we could to ensure his art was made available to a wider audience, through whatever means we were able.

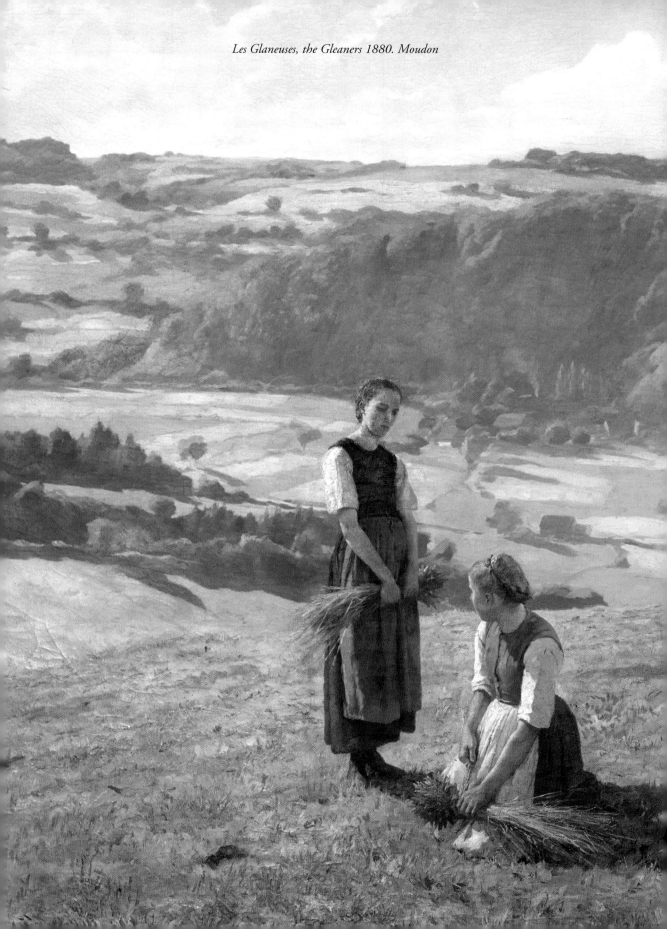

Les Glaneuses, the Gleaners 1880. Moudon

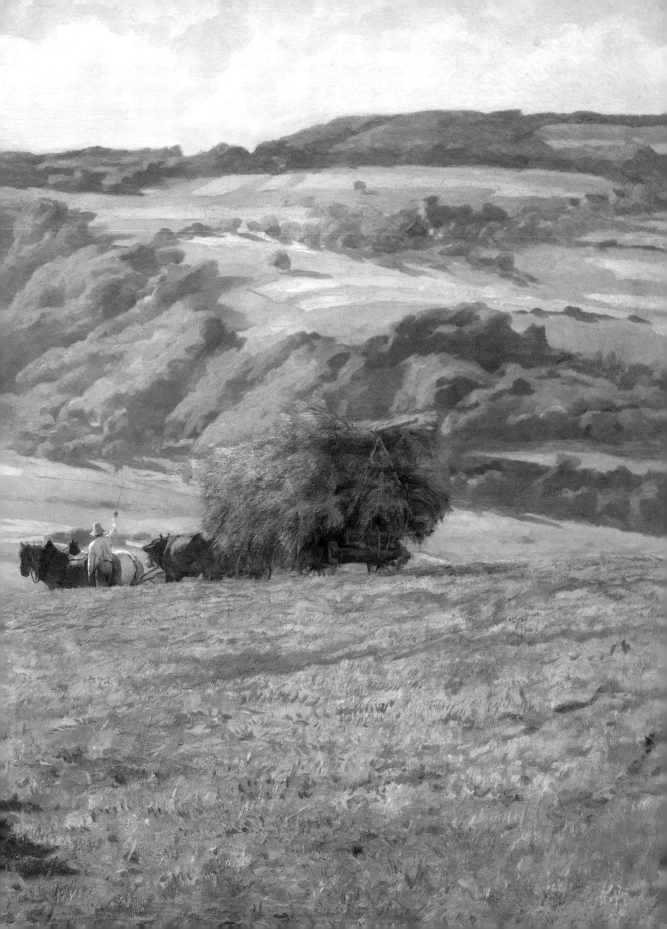

ARTIST OF PRINCIPLE

EUGENE BURNAND was a family man of high moral principle. He and his wife Julia, who was very pretty and often served as his model, loved entertaining their many visiting friends, and although the family moved around a good deal they clearly had warm relationships with their community, whether in Switzerland, Provence or Paris, and mixed with the intelligentsia and artistic world of the day. From existing correspondence it is clear that Burnand would not compromise on his principles, and in one letter refused an illustration commission because he felt the book was not suitable for his wife or daughters to read. He appealed to the writer to share his principles. We do not learn the outcome, but it was such a charming letter that one can guess he did not lose a friend.

He had friends in both French and German speaking Switzerland, and loved the culture of both France and Germany. He was of course distressed at the outbreak of war between the two countries, but firmly sided with the Allies because he found the growth of German militarism abhorrent. Though Switzerland remained neutral, several of his relatives, his sons and nephew, joined up to fight for France. He greatly admired the bravery of the ordinary French soldiers, familiarly known as "les poilus" – the equivalent of the English "Tommies". He was not so enamoured of the higher-ranked officers, whom he blamed for mismanagement.

When he was confined to Switzerland by the outbreak of war in 1914 he was working on a set of portraits of his Swiss countrymen, drawn from his neighbourhood in the Vaud region near his family home at Sépey. He had already produced stunning examples of rural life and work in the

region, strongly influenced by Millet and Courbet. His painting of "Les Glaneuses", the gleaners (see pages 22–23), is very reminiscent of Millet's treatment of the theme, set in the glowing landscape of his home valley. He had always painted portraits as well as landscapes, often as commissions for friends, but the series of "Types Vaudois" seemed naturally to prepare him for his greatest final work, the "Portraits de la Grande Guerre".

Burnand started work on the pastel portraits in 1917 in Paris. He took the opportunity of being sent on a diplomatic mission to Paris, and then was able to travel to Montpellier and Marseilles, to seek out subjects for his portraits. His journals record that these soldiers and other personnel were often recuperating there from time at the front, before being sent back to active service, particularly those from the former French colonies who suffered in cold northern winters. He tells how several of them were invited into his home and entertained, and later became friends and continued to correspond with him. They were paid for sitting for him, but many considered it an honour and refused payment.

At the end of the war the family moved back to Paris, where they remained until the artist's death. There were still many military personnel present in Europe after the war had ended, so he was able to continue with his series of portraits. His health was declining, and though he had previously painted in oils "en plein air", often on a large scale, this project could be carried out in his studio, and the medium of pencil and pastel drawing could be done quickly on the spot, sitting "knee to knee" with his subjects. In all he completed 104 portraits, and there was one of a nurse on his easel, signed, when he died in February 1921.

THE GREAT WAR PORTRAITS

F ROM THE AGE of the Enlightenment onwards there was a strong belief in the progress of mankind, and after Charles Darwin had introduced ideas of the evolution of the species from a scientific point of view there was a commonly held view that the civilized nations had a duty to bring their colonial subjects up to their own standards of behaviour and attitudes. Anthroplogy was in its infancy, and travels abroad and explorations of the cultures found in Africa, India and Asia held a great fascination for Europeans. Artists were equally interested in portraying people of different cultures, for example Paul Gauguin famously painted the people of Tahiti. Burnand was no exception to this interest in differences of physical appearance, character and culture.

Those looking at his portraits of the First World War combatants have commented on the humanity and respect with which they are depicted. He may well have held the French soldiers in high esteem, but he gives equal respect and attention to detail in his portraits to those from colonial backgrounds, whether from African countries, including Algeria, Tunisia and Morocco, India, Pakistan, China or elsewhere. His deeply religious nature would have made him regard them all as part of God's creation, and he expected to find "that of God" in every man or woman. There is not one ounce of racial prejudice in his work, and indeed quite the reverse: I think he intended his portrait gallery to be a kind of lesson or parable in itself, about how to honour people of so many different ethnic and cultural backgrounds who were drawn into the conflict. He is saying to us, all these fought for what they believed to be right, and we owe them a debt of gratitude. It is a profound and humbling statement.

There is compassion too, for those who were exploited and given menial tasks, such as the Chinese labourers carrying heavy loads, the trench diggers and porters of supplies. The Americans would not let their black soldiers carry arms, and the French army had strict hierarchical rules, ensuring white officers supervised the colonial troops, some of whom would have been conscripts. Robert Burnand's commentaries must have been based on Eugène's own views as expressed in his journals, and they reveal considerable sympathy for the sufferings and hardships endured by the troops. Occasionally there are rather stereotyped views of particular ethnic groups' characteristics in the texts, and it would not be surprising if Burnand shared those attitudes, so common at the time. But extracts from his *Liber Veritatis*, an account of his work, quoted by his son René in the biography, reveal an engaging and fun-loving relationship with some of his subjects. He describes one rather fearsome looking soldier from New Caledonia, the Loyalty Islands in the Pacific, as being of a gentle disposition, eating cherries and singing hymns in their bedroom in Marseilles! This small anecdote gives the flavour of the way he befriended the men he painted, his kindness and their gratitude to him and his family, which was often maintained after the war was over.

EXHIBITIONS

THERE WERE TWO exhibitions of the pastel portraits in Paris in Burnand's lifetime, the first at the Musée du Luxembourg in 1919, where 80 paintings were shown. As his biographer, René Burnand, describes the success of the exhibition, "All Paris was there!" The second was held a year later in 1920 at the Brunner Gallery and drew huge crowds – it was estimated at least fifteen thousand people visited the exhibition, which was widely acclaimed. The organisers were the publishers Crété, and the catalogue had a preface by Louis Gillet, renowned art critic. It was proposed to make the 100 pictures shown there into a book, to mark the success and public appeal of the exhibition. This de luxe book was published in 1922, shortly after the artist's death, with a handwritten foreword by Marshal Foch, and a lengthy introduction and appreciation of Burnand's artistic worth by Louis Gillet.

The catalogue for the first exhibition lists the works in no particular order, with all ranks and contributors to the war effort given equal significance. In fact in that exhibition most of the portraits were of ordinary soldiers, with a couple of nurses and a chaplain. The later Brunner gallery catalogue of 1920 is more systematic in its order, perhaps with the planned publication of a book in mind, and there are generals and admirals added. Burnand had also intended to have Marshal Foch and General Castelnau sit for their portraits, since they were his friends, but this was prevented by his illness and death in February 1921.

The list has one very significant feature: the soldier chosen to open the series, specifically by Burnand, is a simple French foot soldier (*fantassin*), typical of his comrades, and the backbone of the French Army, whose courage was

so much admired by the artist. Thereafter the list is arranged by country of origin of the troops, including their colonial soldiers, beginning with France, then Britain with its overseas territories, the United States, Italy, Japan, Belgium, Serbia, Russia, Romania, Greece, Portugal, Montenegro, Poland and Czechoslovakia. This order was retained for the publication of the Crété book and for the subsequent hanging of the originals at the Musée de la Légion d'honneur, together with its recent publication, "Portraits de la Grande Guerre" to mark the centenary of the outbreak of the 1914–18 war. This was believed to be in line with the artist's wishes, and it was a condition of the gift of the donor to the museum, American philanthropist William Nelson Cromwell, who stipulated the portraits should be kept together as the series the artist had planned.

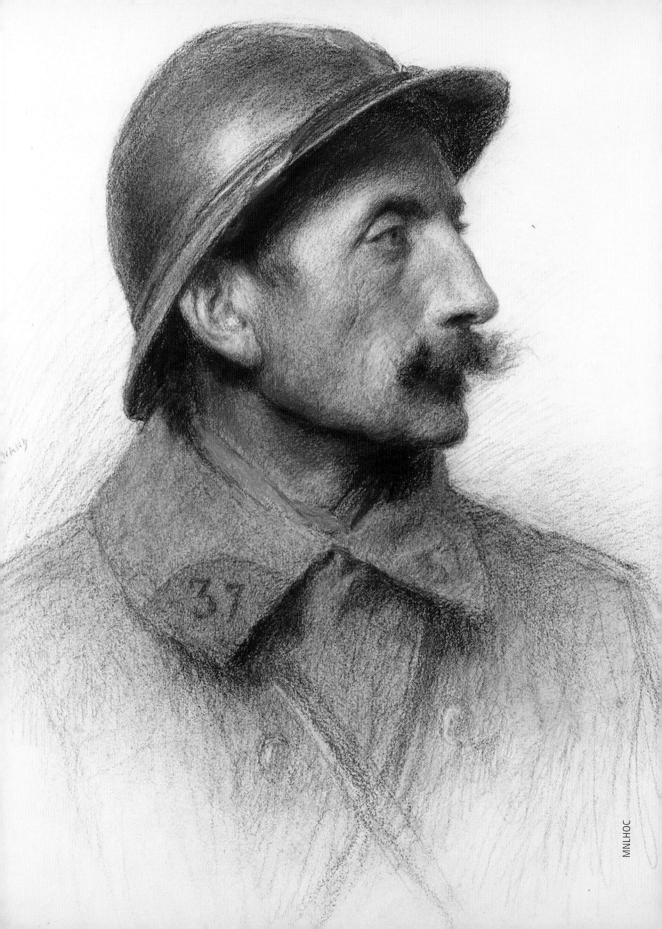

FANTASSIN DESVIGNES, FRENCH INFANTRYMAN

This is the soldier from Burgundy whom Burnand chose as the epitome of the simple yet noble French infantryman to open his series of portraits. He was given this honour because he represented thousands upon thousands of his countrymen, from all parts of France, who obeyed the call to defend his homeland, wherever it might lead him. He served in the 37th division, as you can see from the faded number on the collar of his greatcoat – a division which took part in all the major battles of the war, in which so many of his compatriots laid down their lives. He was at Verdun, and the Chemin des Dames, and battles too numerous to mention here, obeying orders and playing the part he was given without complaint. Burnand has faithfully portrayed the worn face under the shining metal of his helmet; his eyes stare into the distance, remembering the horrors of scenes he has witnessed. There is bravado in his wispy unkempt moustache, and he holds his head high, alert and ready for the fray. He represents the fine, slender and sensitive features of the French soldier-type the artist so much admired. No wonder Burnand wished to honour him.

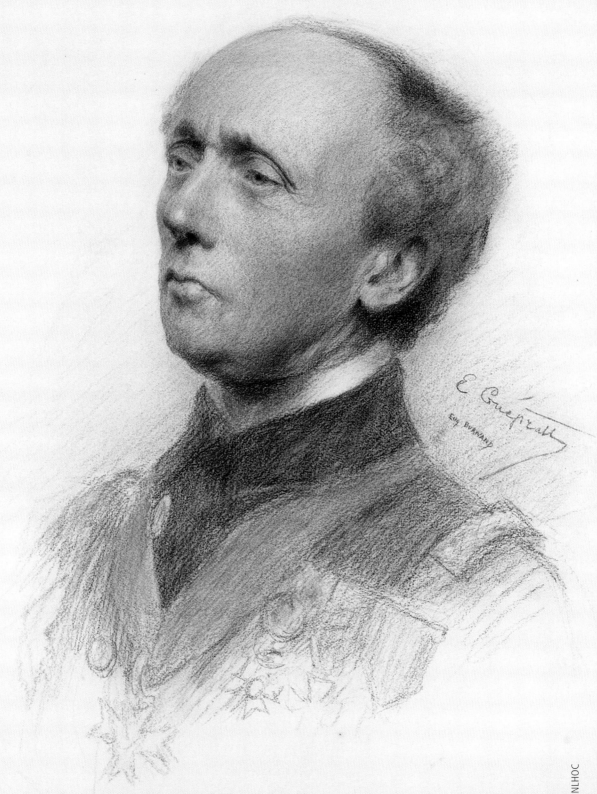

E. Guepratte

Eug. BURNAND

VICE-ADMIRAL EMILE-PAUL GUÉPRATTE, FRENCH NAVY

A rear admiral of France in 1914 at the beginning of the war, Vice Admiral Guépratte was viewed as a dashing figure, admired by the British, and was nicknamed by them the "Fire-Eater". He headed the joint Franco-British Mediterranean fleet in the Dardanelles campaign, and insisted on leading the warships into the straits and towards Gallipoli, where several ships were lost and sunk in a minefield. He later supported the British troops in their ill-fated invasion. His bravery was admired, but he was deemed too rash by his superiors, and after promotion to Vice-Admiral he was replaced in his command and sent to North Africa for the duration. After the war he became a politician and served as a socialist member of the Chamber of Deputies, before his retirement in 1925. He returned to his native Brittany, from where many French sailors hailed, and subsequently wrote a book on the Dardanelles campaign.

Burnand portrays him as a proud individual, with a slightly haughty expression, adorned with all his various honours and medals, including the Légion d'honneur and the Croix de Guerre.

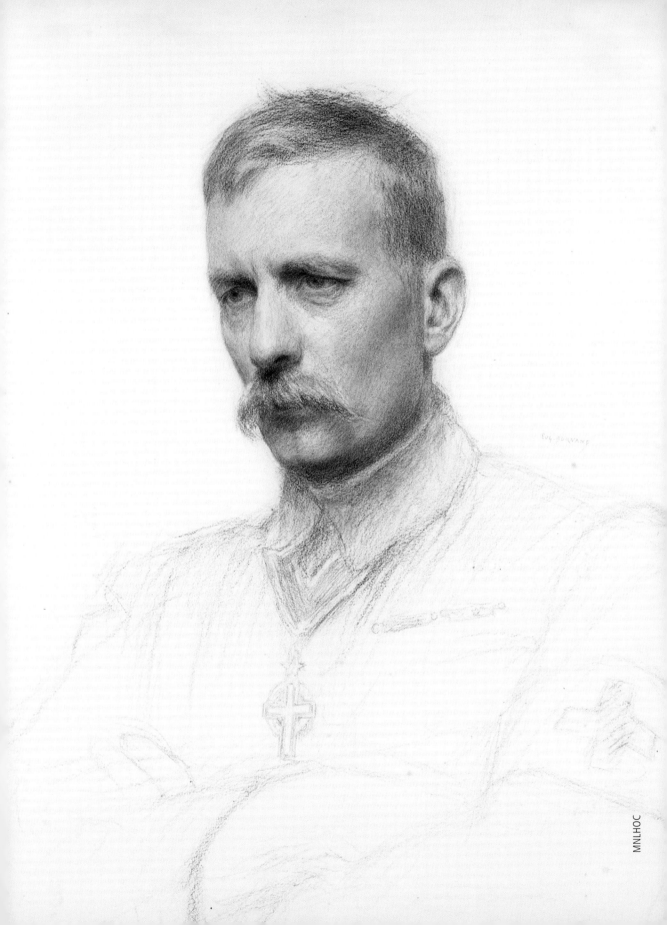

PASTEUR NICK, PROTESTANT CHAPLAIN

Henri Nick served with the First Corps of the French Army for the whole five years length of the war. He was tall and spare, with a slender face made even thinner by the harsh life he led alongside his comrades, sharing all their sufferings and hardships. He was loved by thousands of soldiers, ministering to them quietly and faithfully, bringing comfort to the wounded, the dying, or the simply despairing. He would have worked with the nurses of the Red Cross who were also present with the soldiers, and much beloved by them. He was awarded the Légion d'honneur for his brave service.

After the end of the war he returned to his parish in an industrial working class area called Fives, in Lille. He founded community centres for the poor, fought against alcoholism and set up holiday centres for the children. In the Second World War he helped Jewish people fleeing from persecution and sheltered the Resistance. He died in 1954. He is still remembered in Lille, and there are several books about him and his work.

Burnand has captured his direct gaze, his deepset eyes burning with faith, his resolute manner. A fine man who has weathered much and survived, dedicating himself to serving others and fighting injustice for the rest of his life.

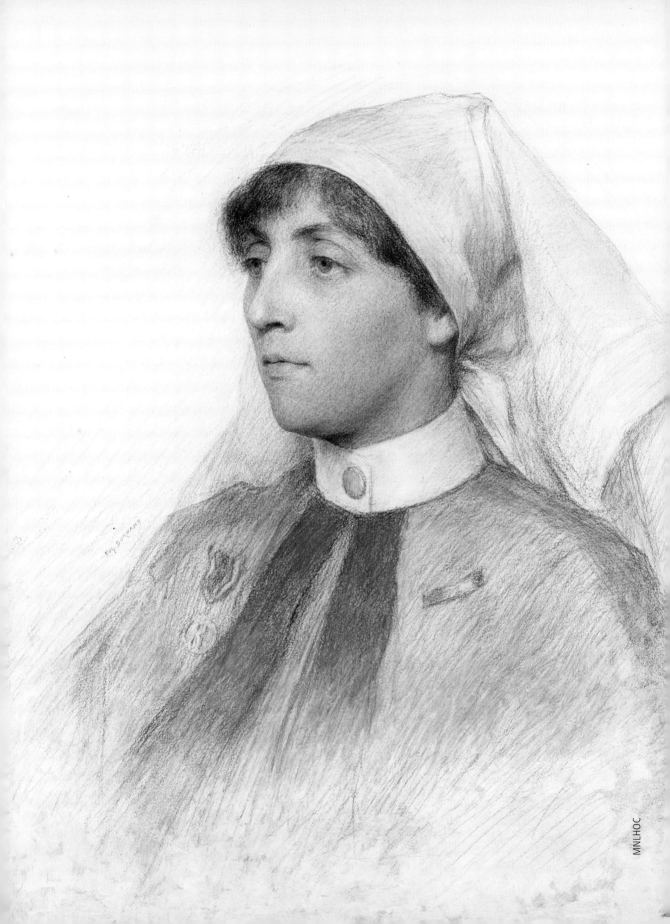

STAFF NURSE, LATER MATRON, MARY MCLEAN LOUGHRAN, QUEEN ALEXANDRA IMPERIAL NURSING SERVICE

Burnand includes five nurses in his series of portraits: two are French, one American, one male Malagasy nurse or orderly, and this one, an Australian, from Melbourne, serving with the British Army in France from 1915 until the end of the war. The bravery, skill, and tender care of the nurses are much praised, and in the case of nurse Loughran her ability to command respect. She reigned over a "field ambulance", and brought order to the challenging task of managing a mobile medical unit or field station to treat wounded soldiers, very close to the combat zone. She was mentioned in dispatches in 1916 for gallant and distinguished conduct in the field, and received a Royal Red Cross medal (first class) from the hands of the King for her war service.

Burnand has caught in this portrait the expression of firm determination combined with gentleness in her beautiful eyes, which made her a successful leader. It also emphasises the importance of the caring role of the brave women who were alongside the soldiers and shared their harsh life, nursing the wounded in terrifying conditions. The nurses' contribution was invaluable to those men whose lives they saved, and to those to whom they brought comfort in extremity. English readers will be familiar with Vera Brittain's account of nursing the wounded as a VAD in France in the 1914–1918 war, *A Testament of Youth*, and the recent (2015) film of her memoir brings home vividly the appalling suffering there.

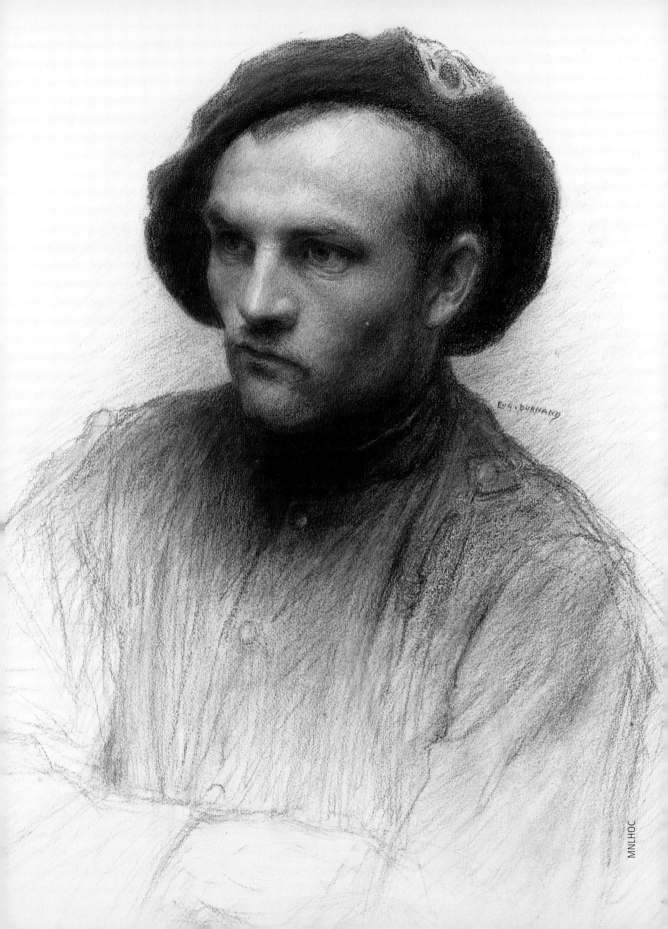

FERNAND RUAN, CHASSEUR ALPIN

Fernand Ruan, from the Cévennes, served with the élite infantry corps of the "Chasseurs Alpins", literally mountain hunters. These soldiers were drawn from mountainous areas and trained in combat in that terrain. They fought with a close-knit group from their own region, and were known for their strong esprit de corps and traditions. Unlike the rest of the French Army who wore horizon-blue uniforms, they retained their practical, tough, dark-blue loose fitting jackets, worn with an iconic wide beret pulled down over one ear, adorned with the gold insignia of their regiment, the hunting horn. This can be clearly seen in Burnand's portrait.

Their adversaries called them the "Blue Devils": they were a strong and effective infantry force. In winter they were trained to use skis: one can imagine them appearing swiftly over the horizon and striking fear into the enemy. Fernand Ruan's regiment took part in some of the fiercest battles of the war, particularly in the Vosges region: notably Hartmannswillerkopf, the Chemin des Dames Ridge, Malmaison, Montdidier, Noyon, Chateau Thierry. The chasseurs defended the mountainous borders of France, Switzerland and Italy.

They had a strong musical tradition and their military bands were known for their proud "fanfarons", signalling victory.

Fernand Ruan survived the war, and when Burnand painted his portrait he was probably recuperating from an injury.

Recently a great-granddaughter who lived with him as a child found this portrait of her much loved papé on the website, to her family's great delight. They were thrilled to discover that it was in the museum of the Légion d'honneur in Paris. Céline, who knew him until he died when she was ten years old, sent a photograph showing him recovering from being wounded, with his arm in a sling, alongside comrades and nurses, which must have been taken during the war in about 1917. He is in the centre, front row.

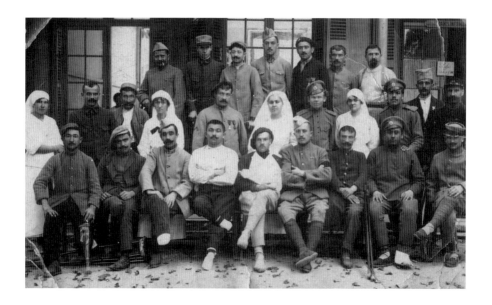

Fernand Ruan recuperating after being wounded (1917)

Fernand married and had children and grandchildren, as well as taking on the care of Celine's mother when she was small. He was a well-loved family man who lived to the age of 90, dying only in 1981. His family are proud of his memory.

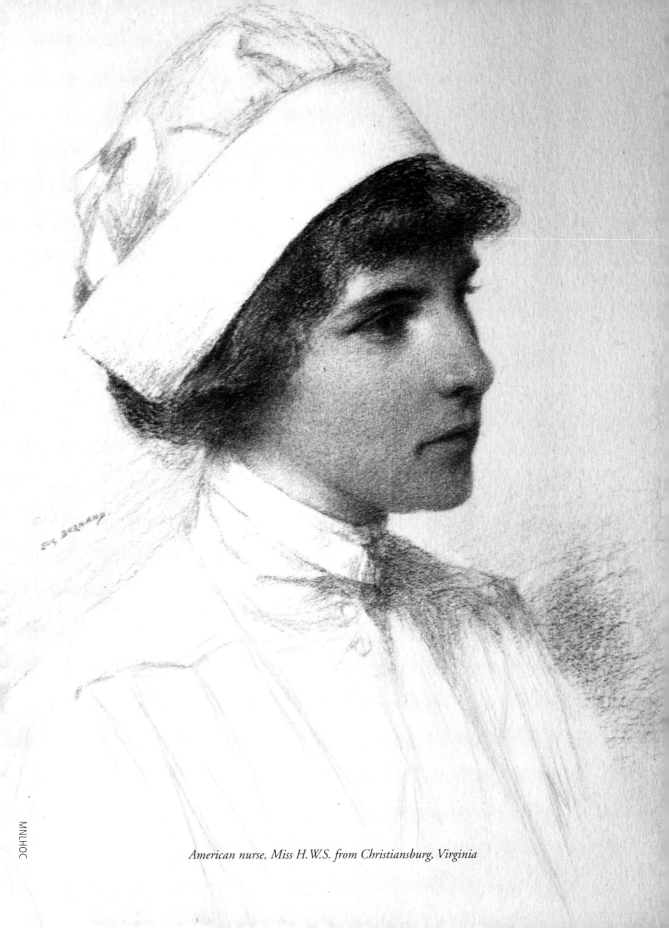

American nurse, Miss H.W.S. from Christiansburg, Virginia

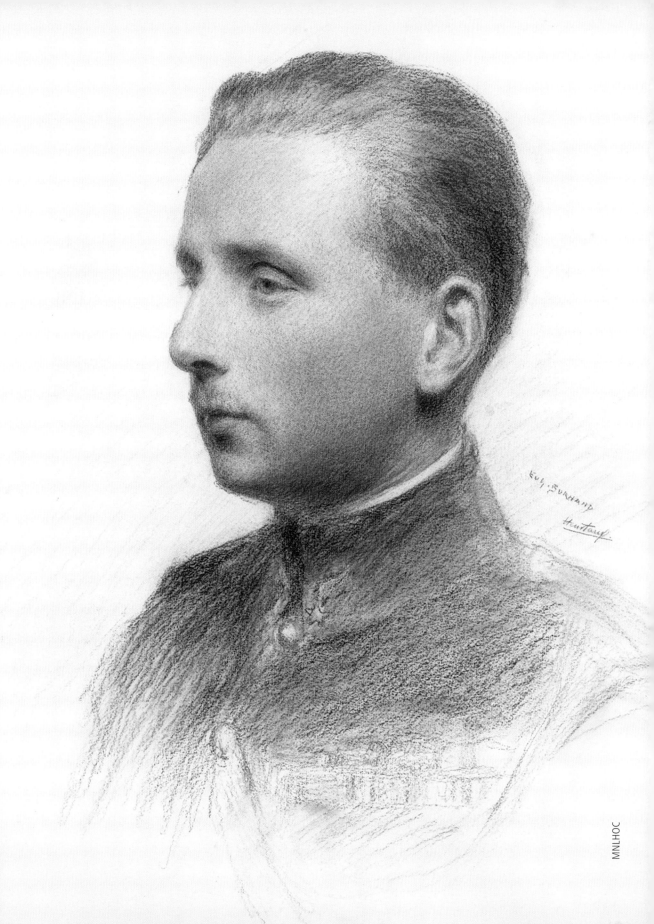

CAPTAIN HEURTAUX, AIRMAN, COMMANDER OF THE 3RD SQUADRON, LES CIGOGNES (THE STORKS)

Captain Alfred Heurtaux trained at the Saint Cyr military academy and became an accomplished aviator, serving in a famous squadron called the storks, Les Cigognes, for the emblem they carried on their planes. He gained considerable success as a fighter pilot, downing several (21) enemy planes, and providing reconnaissance photographs for the ground troops. He was severely injured in 1917, but continued to assist the war effort by giving lectures on aerial fighting tactics in America and elsewhere. He received the Légion d'honneur and Croix de Guerre. After the war he was president of aviation associations and was involved in the automobile industry. In the Second World War he became a colonel, and joined the resistance when France was occupied, providing valuable reconnaissance information to the Allied troops. He was captured and spent several years as a prisoner of the Germans, being eventually taken to Buchenwald, from where he was liberated by the Americans in 1945. He was promoted to general, and given further honours by the French State.

Burnand shows him as a dashing young man with a fashionable short moustache, favoured by the airmen, and his ruddy complexion conveys his youthful energy and enthusiasm for his role, with a touch of seriousness in his expression too.

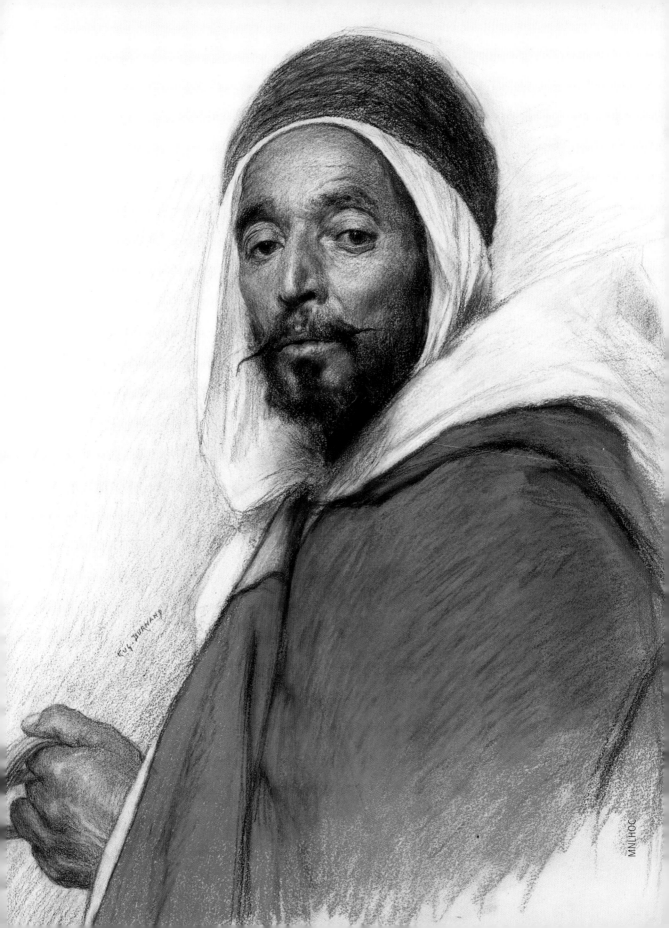

MOHAMED OSMAN – ALGERIAN SPAHI, CAVALRYMAN

The French Army recruited over 600,000 soldiers from its colonies, of which nearly 300,000 were from North Africa – Algeria, Tunisia and Morocco. The majority of these were sent to fight on the Western Front.

The spahis were cavalry from the Maghreb, indigenous tribesmen known for their bravery. Mohamed Osman, shown full face and noble in his bearing, is wearing the traditional flowing red burnous or cloak, with arab head dress of white, bound with camel hair. He would probably have been a Muslim, and Robert Burnand's commentary makes reference to his beliefs. The reins of his horse can be seen in his hand.

There were Algerian, Tunisian and Moroccan spahi regiments, and contemporary photos exist of them serving in France and Belgium, wearing both traditional dress and later an amended khaki uniform, which Burnand laments. He also describes that when they were sent to Flanders to fight, in unaccustomed flat and wet country, they used to exercise their horses by galloping along the beach with their red cloaks flying. One can see how this would have appealed to the artist, though he is clear-sighted about what they suffered and achieved in a situation so foreign to them.

The picture below is of a Moroccan group of spahis in Belgium, wearing the same dress.

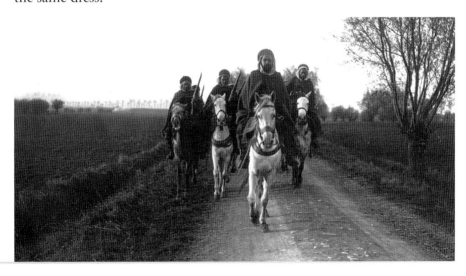

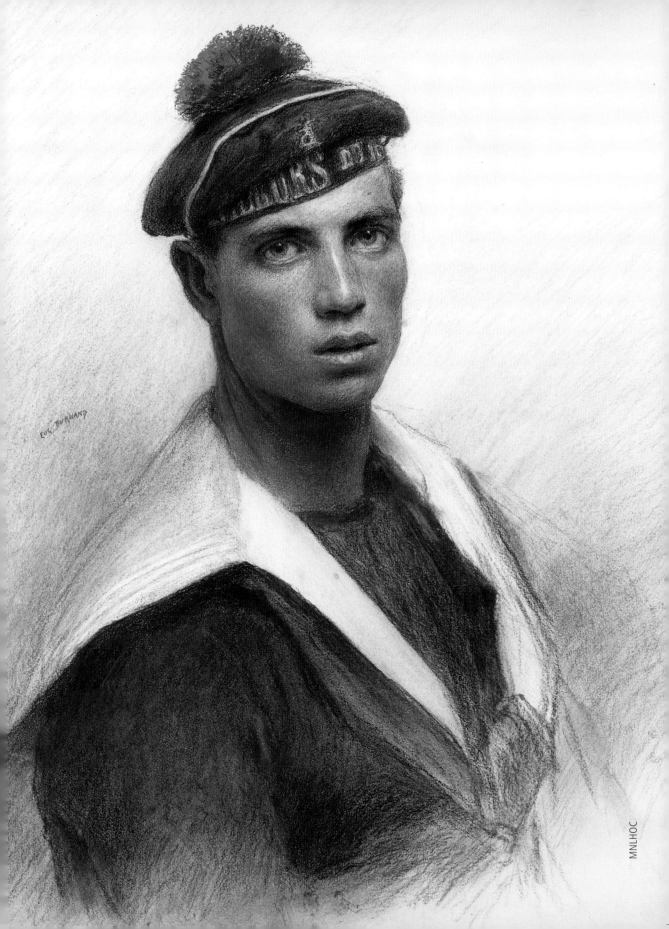

ANGE ORSI, SAILOR, FROM AJACCIO, CORSICA

Although the majority of servicemen portrayed by Burnand are soldiers, he does not ignore the other services which contributed to the war effort, and he painted several sailors, whose role in keeping the army supplied and guarding convoys was vital. The most charming portrait, and apparently the most often reproduced of the series, is of a young sailor named Ange Orsi, from a group named Les Pompons Rouges, for obvious reasons. He was from Ajaccio, Corsica. Many other sailors joined the navy and came from the coastal regions of France. He also portrays a number of British, American and Italian seamen who participated in the war, and even includes one fine Japanese naval quarter master from their fleet in the Mediterranean, the Japanese having sided with the Allies in 1914.

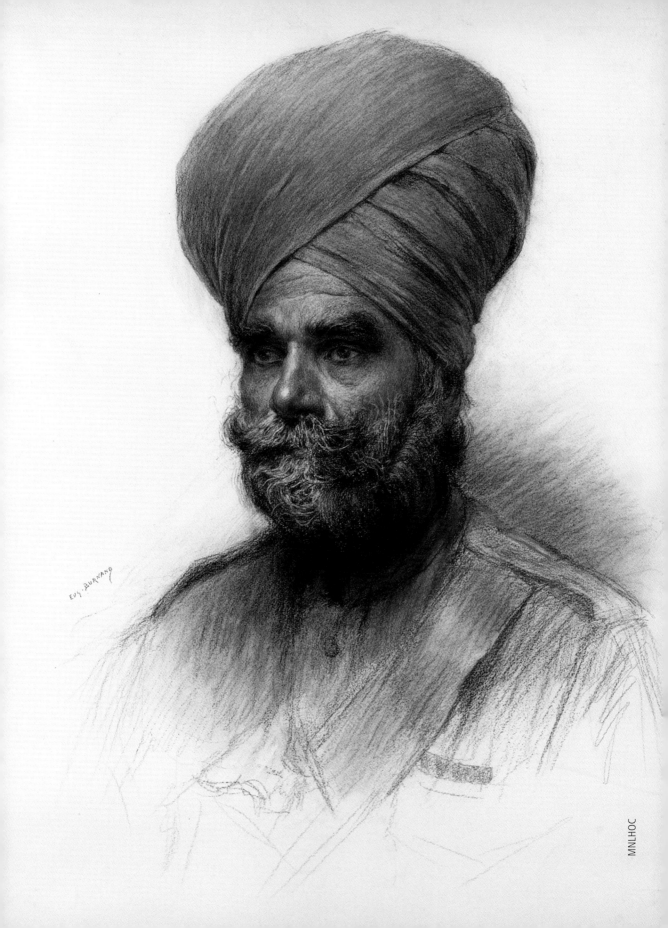

SUNDER SINGH HALDICE, SIKH NON-COMMISSIONED OFFICER

This Sikh soldier was part of the British Army, which relied heavily on its Indian troops during the war, as they were brave and accomplished fighters. They were particularly important in the early stages of the war in the battles of the Marne and Ypres, before British reinforcements had arrived. Later they also served with distinction in Mesapotamia (present day Iraq) and in the Gallipoli campaign alongside the ANZAC troops. Burnand captures this soldier's nobility and pride in his faith. His hair is twisted up under his turban, so elaborately tied and so beautifully painted.

The Indian Army contingents took heavy casualties, and many of the Indian soldiers who were wounded on the Western Front were transported to England for medical care and recuperation. The Royal Pavilion in Brighton, the Prince Regent's oriental fantasy palace, was turned into a hospital for this purpose, where the soldiers received excellent medical care and wrote letters home marvelling about how well they were treated. There were separate kitchens catering for Hindus, Sikhs and Muslims, and places of worship to meet their respective faith needs. There is a monument to those who died there, above Brighton on the Sussex Downs, the Chattri, where a ceremony of remembrance is held each year.

A memorial statue to the Sikh soldiers of the First World War has also recently been placed in the National Arboretum in Staffordshire, England, to honour their memory.

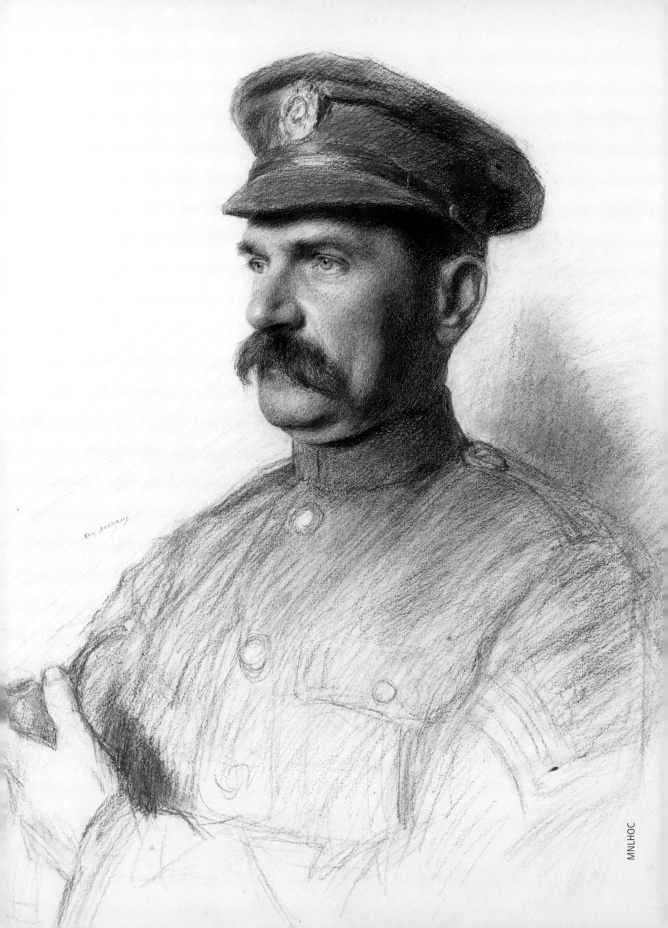

ROLAND EDWARD PARKER, BRITISH SERGEANT FROM COVENTRY

Roland E. Parker was part of the many British contingents sent over to France to fight on the Western Front, and we know he survived the war because there is archival correspondence between him and the artist. Burnand records in his diaries that Sergeant Parker was in civilian life a Sunday School superintendent in Coventry, who told him that he used the book of biblical Parables, Les Paraboles, translated into English, beautifully illustrated by Burnand in 1908, as an aid to his teaching. This coincidence must have struck the artist as quite amazing, as well as gratifying. The two men kept in touch after the war.

This British infantryman must have been fairly typical of his rank, and looks older than many of the soldiers portrayed, rather more craggy and experienced. He is shown holding a pipe in his hand, a homely touch by Burnand, recognising their friendship and easy relationship.

Burnand pays tribute here to the British contribution to eventual victory in the war. He had visited England before the war to discuss publication of a book illustrating the life of Saint Francis, subsequently published by J. M. Dent & Sons, *The Little Flowers of St. Francis*, and he greatly admired the country. He loved the books of Dickens and Walter Scott. He regularly sent pictures to the Royal Academy summer exhibition and had exhibitions of his paintings in various British galleries including the Walker Art Gallery in Liverpool. He was presented to Queen Victoria, as she had expressed a wish to see his paintings.

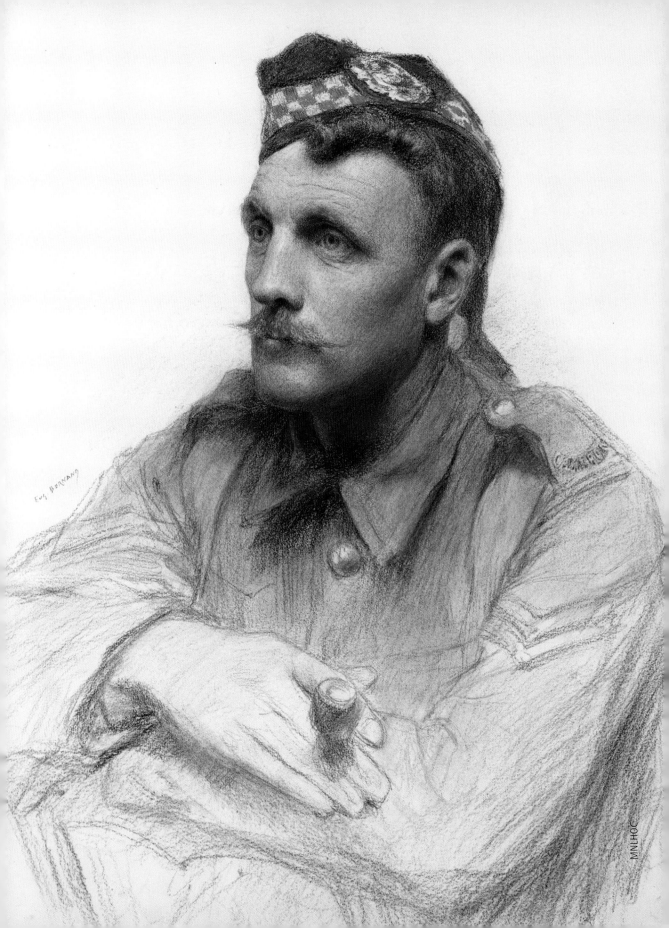

SCOTTISH NCO

There is a story told by Louis Gillet in his preface to "Les Alliés", related to him by Eugène Burnand, that a Scottish soldier travelling from Glasgow to join the Allied troops was ordered to present himself at Burnand's address in Paris. He thought he was on a special mission, and when he met the artist and was told he was to sit for his portrait, he broke into hysterical laughter. This must have been the very man. Several battalions of Scottish soldiers fought heroically in the worst battles on the muddy fields of Flanders, at the Somme, the Marne, Ypres and in many other famous engagements. Their kilts and hats were adorned with their special tartans, they marched to the skirl of the bagpipes, and were much valued comrades in the British Army.

The artist gives detailed attention to this young soldier's thoughtful clear eyes, his wavy hair under his smart Glengarry cap, and the comforting pipe in his hand. He wished to show the value of the disciplined and courageous Scottish contribution to the struggle.

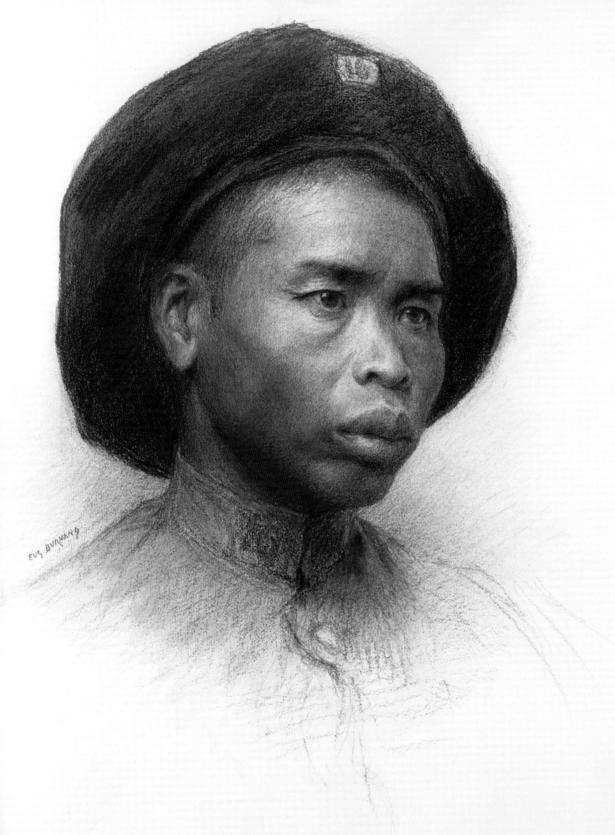

EUG. BURNAND

TONKINESE RIFLEMAN LAI VAN CHAU (FROM SAIGON)

This beautiful portrait reveals the sensitivity with which Burnand drew and used his pastels to accurately represent the features of a man who would have seemed quite mysterious to him, coming from French Indo-China (present day Vietnam). The colour of the glowing skin, the little folds of flesh over the brown almond shaped eyes, the full mouth and rather inscrutable look, are all faithfully captured here. Burnand records his surprise that when he nervously showed the man his portrait he marvelled at the painting, saying, "Is that me?" And exclaiming that it made him look handsome!

Lai Van Chau is wearing an old fashioned beret, which the Asiatic soldiers were allowed to continue to wear for the duration of the war, and it has his battalion number, 16. Others wore conical bamboo hats. There was some concern in the French army leadership about creating separate units of different ethnic groups, for example an Indo-Chinese or Pacific one, as they were dubious about their loyalty and fighting ability, which meant they were often mainly deployed in logistical roles away from the front lines.

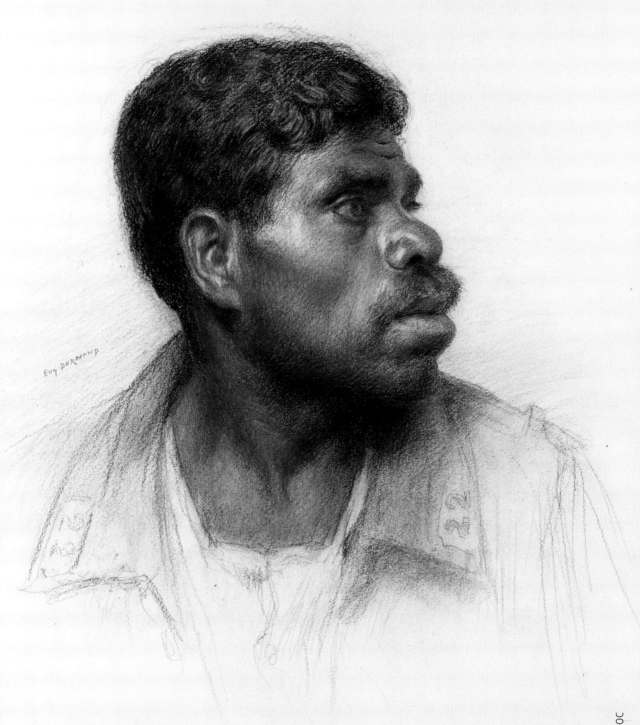

EUG. BURNAND

ERNEST INGHA FROM NEW CALEDONIA MIXED PACIFIC BATTALION

Burnand was very impressed with this man's physique, and states that although his appearance might seem fearsome, and he had taken part in battles in Picardy and elsewhere, he was actually very gentle in temperament. The artist has shown him facing him but looking to one side, to capture the strength of his jaw line and neck, with his shirt open, and his battalion number, 22, showing.

It is Ernest whom he took into his home, and he describes him eating cherries and singing protestant hymns in their family bedroom in Marseilles. It is here we see Burnand's interest in physiognomy to the full, managing to capture strength and gentleness at the same time with consummate skill.

Certain French colonial soldiers were believed to come from warlike fighting stock, according to stereotypes of the time, and the Kanaks were recruited as one such group, as were the "Tirailleurs Sénégalais". This was a name given inaccurately to several of the black African units, many of whom actually came from Sudan and other African countries rather than Senegal, though historically Senegal was where the first such regiment was formed. The Senegalese were often well educated and well trained, and became officers in the French Army, giving invaluable service, particularly in fierce battles like Fort Douamont at Verdun.

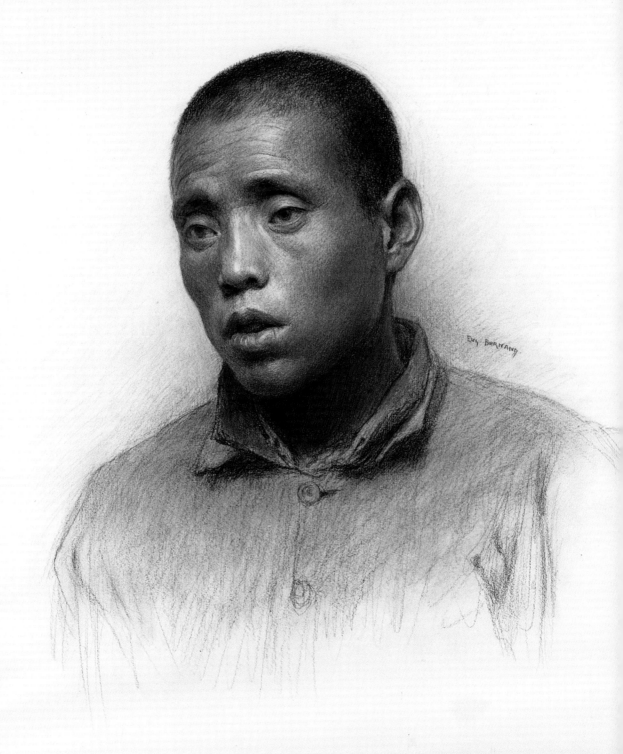

Travailleur Chinois, Chinese Labourer

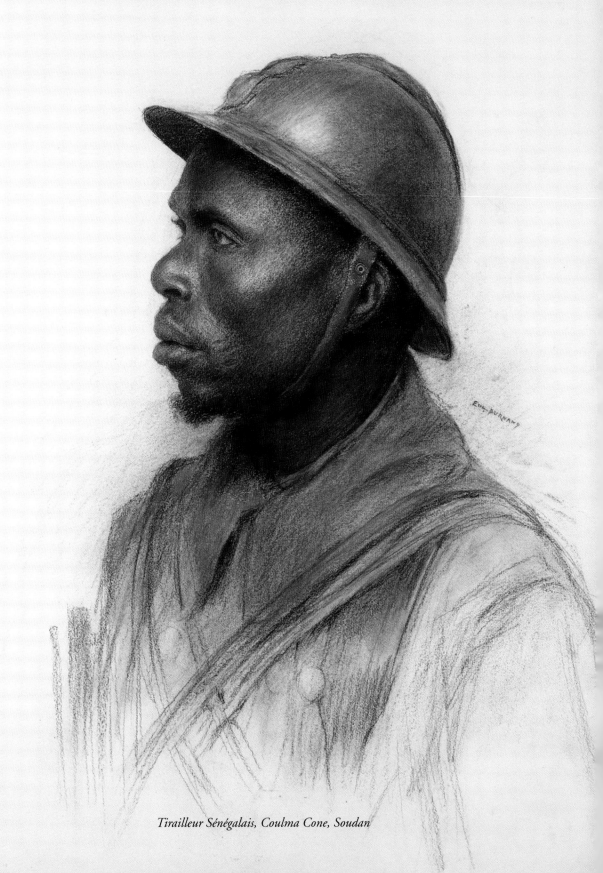

Tirailleur Sénégalais, Coulma Cone, Soudan

The French and British armies both recruited large numbers of Chinese labourers to do the heavy work of road building and maintenance necessary to transport troops, munitions and supplies to the front. They also were valued as competent trench diggers and mechanics, maintaining vehicles and tanks. Robert Burnand's commentary graphically describes the harsh conditions this Chinese labour force worked under, particularly along the "Sacred Road" to Verdun, where there was a continuous stream of vehicles passing and re-passing, day and night, covering the Chinese workers in a permanent layer of yellow dust and mud. Other colonial nations also were recruited to do the heavy work of trench digging and maintenance, but none on the scale of the Chinese workers who had contracts of employment for three years, and were more like economic migrants than combattants. This of course did not necessarily protect them from being killed by shells as they worked, nor from dying of disease. Their work was a vital part of the military campaign of the allies.

In 1917 the USA entered the war, and Burnand describes his visit to the American army barracks to select some suitable subjects to draw for his series. The men stood to attention as they were inspected, fearing he was looking for someone who had committed some offence, not realising the purpose of his visit. They were very amused and relieved when they were picked out to be the artist's models. There were already Canadian troops operating under British command, such as the example here of a Canadian from Winnipeg, who Burnand says was particularly proud of his Indian blood – his grandmother was an indigenous North American Indian or "first nation" Canadian. Altogether 600,000 Canadians served in the war and their greatest military feat was the capture of Vimy Ridge in 1917.

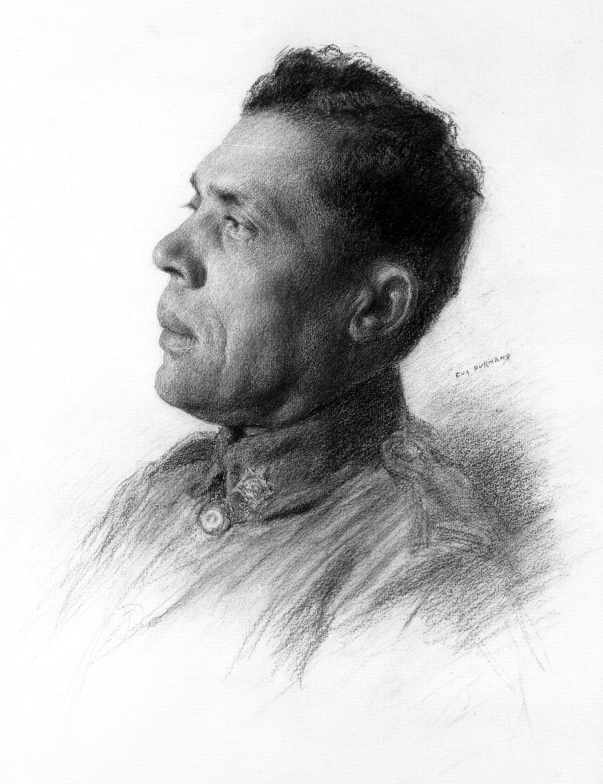

Canadian mixed heritage soldier C. E. Parker from Winnipeg

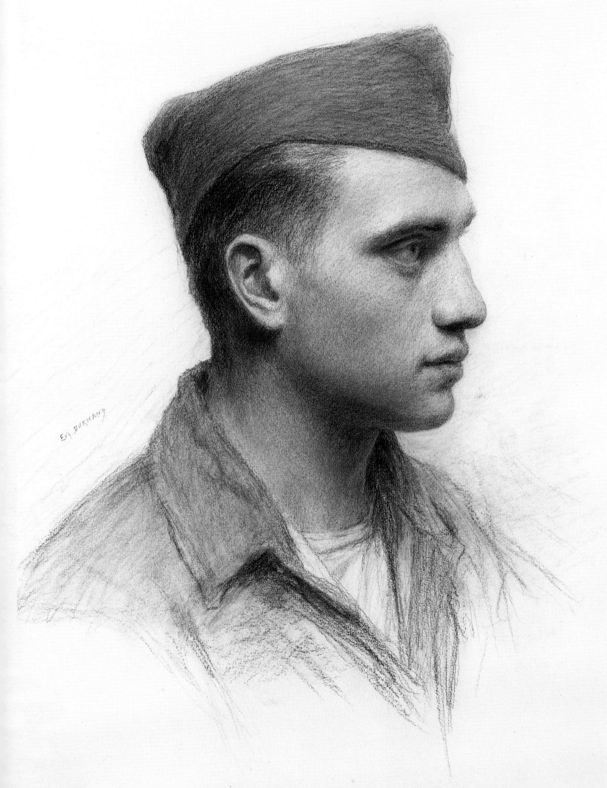

American infantry soldier Will A. Davis from Indianapolis

The Americans had to bring in conscription to raise an army of two and a half million men, often popularly referred to as "doughboys" or Sammies. There were many black African American soldiers too, who were resentful at not being trusted to carry arms. The racial prejudices of the times and fears of insurrection on the part of both the British and French army chiefs soon gave way to the need for combat-hardened soldiers as losses were sustained. These men later became an indispensable part of their armies, fighting alongside their white comrades, much to the horror of their German adversaries, who tried to ridicule the idea that the Allies were using blacks to defend civilisation, since they saw these troops as uncivilized "savages", and used shocking racist propaganda in newspaper illustrations to try to discredit them. Burnand would have hated this, and I believe that his series of pastel portraits was his statement to counter these unpleasant views.

The black American soldiers in France brought their music with them, and it was the first time "ragtime" had been heard there, so they were credited with bringing jazz to Europe!

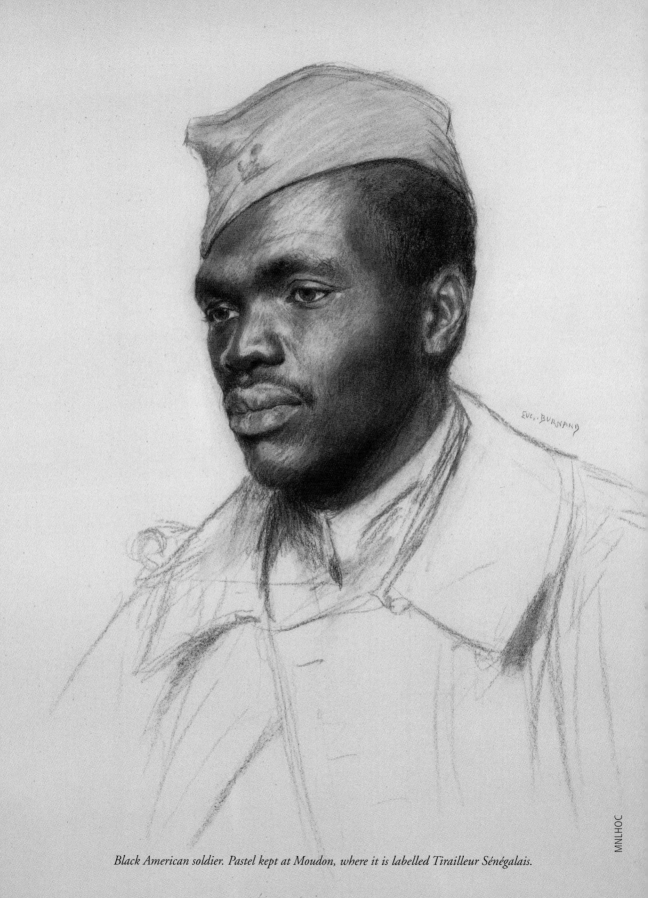

Black American soldier. Pastel kept at Moudon, where it is labelled Tirailleur Sénégalais.

Sénégalais

THE JOURNAL DE GUERRE

Burnand's war diary was thought to be lost, but it was recently (2014) found by his great-granddaughter Frédérique Burnand after searching in an attic in the family home at Sépey in Switzerland, where it must have been kept by Burnand's son René, her grandfather, since he quoted from it in his biography of his father Eugène. It tells of his sympathy with the French, and his concern that much of the Swiss ruling élite favoured Germany, though he did not blame the ordinary German people for the war. His canton of Vaud was La Suisse romande, French speaking, and he had a son fighting in the French Army and many relatives in France.

He received a telegram in April 1917 requesting him to go on a diplomatic mission on behalf of the pro-German Swiss government to visit German prisoners of war in France and report on their conditions and complaints. But when he arrived in Paris to discuss the matter with the pro-German Swiss Ambassador, M.Lardy there, he was received as a minor functionary obeying orders, which disconcerted him. His misgivings about the proposed role eventually made him turn down this mission. He had a conflict of conscience, torn between his love of and loyalty towards France, and his religious beliefs, which considered visiting prisoners as a sacred duty: he could hear the voice of Christ saying "I was in prison, and you did not visit me."

His family and French friends, such as the Director of the Musée du Luxembourg, who pointed out that he was an elected corresponding member of the French Institut des Beaux Arts, were totally opposed to his collaboration in the mission, which must have been requested by Germany itself. His journal records that the opposition of the Director and the Institute was like a "branch thrown to a drowning man" and his emotional turmoil is palpable. The authorities were not best pleased at his refusal, and then took away the diplomatic passport they had given him to enable him to travel there to discuss the issue. This terrible crisis of conscience and the pressure which was applied by the authorities made him ill; he had broncho-pneumonia, (aged 67), and according to his doctor son René the worry could have finished him off. He was confined to bed in his Paris apartment for two months, but he did succeed eventually in persuading them to give him and his wife Julia their passport back, so that they were then free to travel.

The affair left a bad taste, but it had a good outcome – it enabled him to start work on the series of pastel portraits, which he had wanted to do since November 1915. He found models in Paris near his flat, where there was a barracks, and later travelled to stay Montpellier in the autumn of 1917, and Marseille, where the troops were often sent to rest and recuperate. He had the co-operation of the various military authorities for his project, and he and his wife often used to look out for likely subjects in the street or on the train, and invite them to come and sit for him. He threw himself into his work with great energy, passion and enthusiasm, and it kept him occupied right until the end of his life.

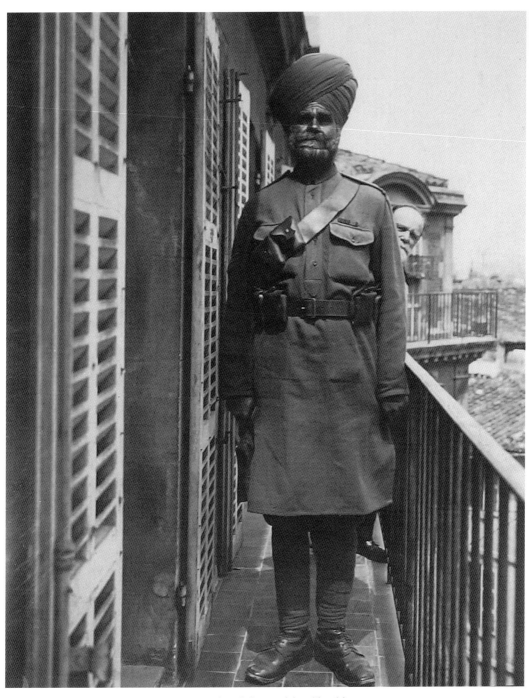

Burnand with his model, Sikh soldier

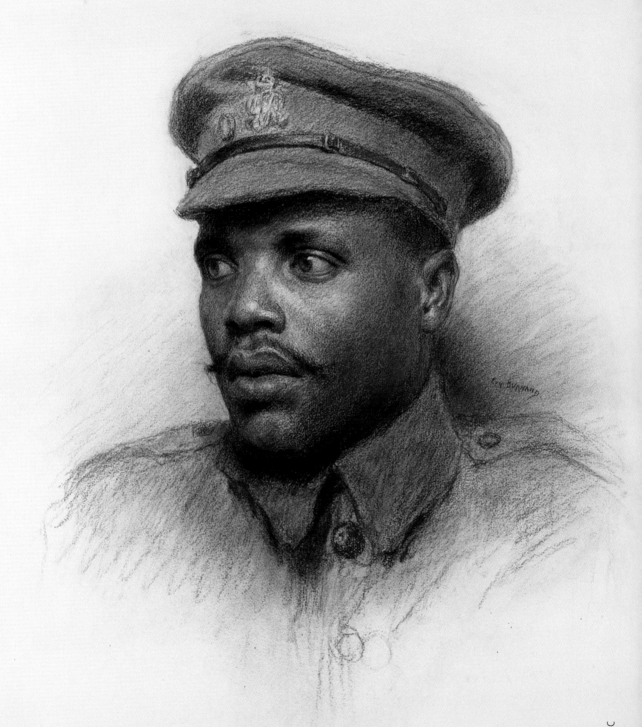

JAMAICAN SOLDIER, CAFÉS JOHNSON

This soldier formed part of the British West Indian Brigade. David Olusaga, in his book "The World's War – Forgotten Soldiers of Empire", reports that initially when war was declared there was great enthusiasm from the British West Indies, and the islanders were keen to do their bit for the war effort. Jamaicans in particular saw the opportunity to put their energies into becoming soldiers, and many sold all they had to pay for their own passage to enlist. They formed a new regiment within the British Army, the British West Indian Brigade, with the support of the Colonial Office and the King. At first they were used as labourers transporting materials, but they had been trained to fight at a military camp set up to receive them in Seaford, Sussex, and they were later deployed along with other British troops, though sometimes segregated from their white colleagues.

This soldier has a sad expression, and one can imagine how they missed the warmth of their home islands. Several Jamaicans died on the passage to Britain because their ship had to divert via Halifax, Nova Scotia due to German submarine action, and they suffered intense cold and frostbite, wearing only their tropical uniforms. Cafés Johnson (a nickname?) seems to be warmly dressed in France. Was it his coffee-coloured skin, that gave rise to his name, or did he enjoy drinking cups of coffee to keep warm?

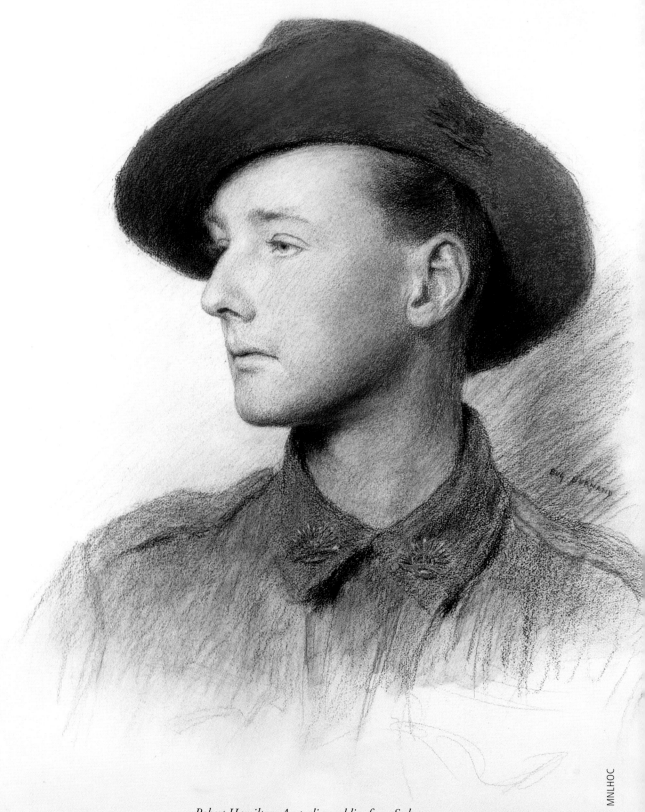

Robert Hamilton, Australian soldier from Sydney

AUSTRALIA AND NEW ZEALAND

The Australian and New Zealand troops formed the ANZAC brigades, and became famous for their brave contributions to the Gallipoli Campaign, the Somme and the 3rd Battle of Ypres, amongst other battles. The Australian Imperial Force contained some 400,000 men, all volunteers, of whom 60,000 lost their lives, and the New Zealand Expeditionary force consisted of 124,000 soldiers of four regiments doing their obligatory national service, named for the military districts of New Zealand. Burnand sees the New Zealander as a sheep farmer from the grasslands, and the Australian as fine specimen of youth trained to fitness of body and mind.

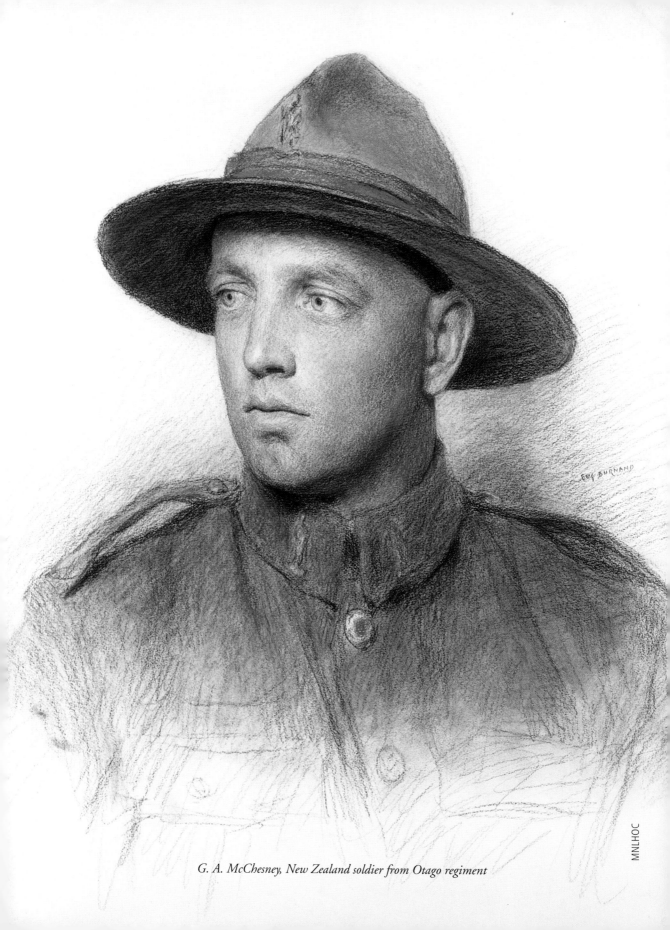

G. A. McChesney, New Zealand soldier from Otago regiment

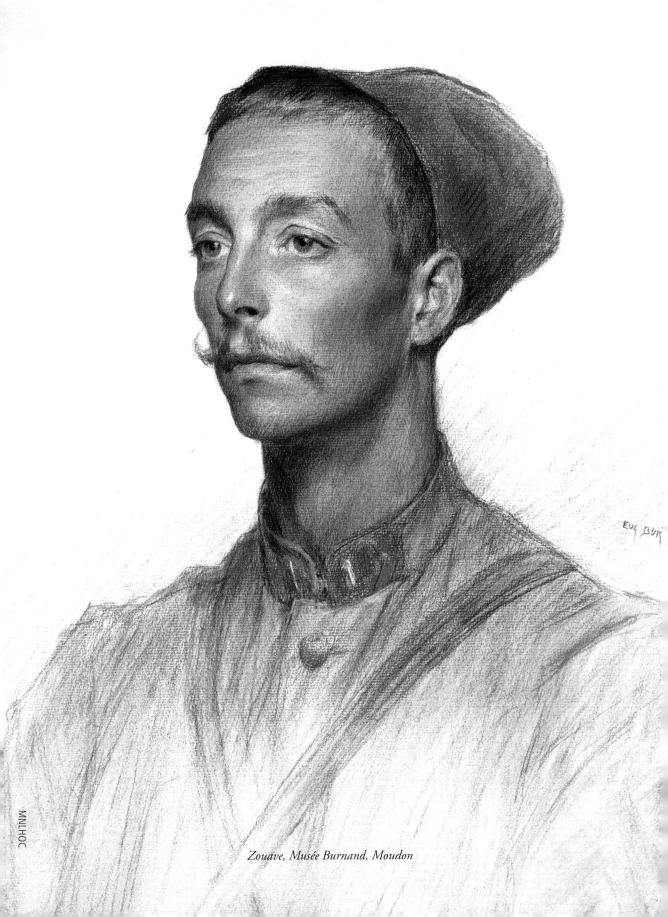

Zouave, Musée Burnand, Moudon

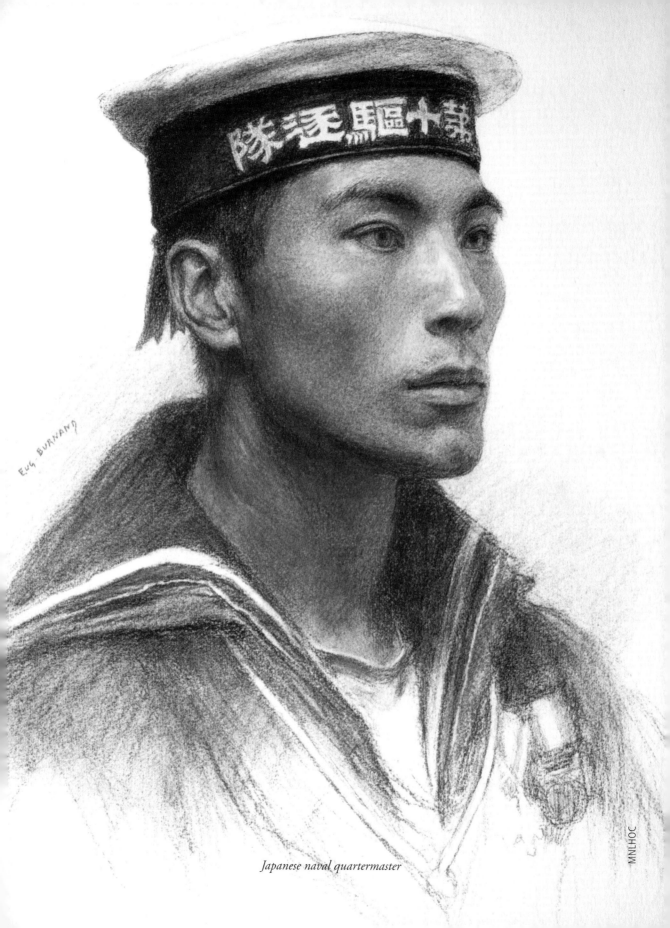

Japanese naval quartermaster

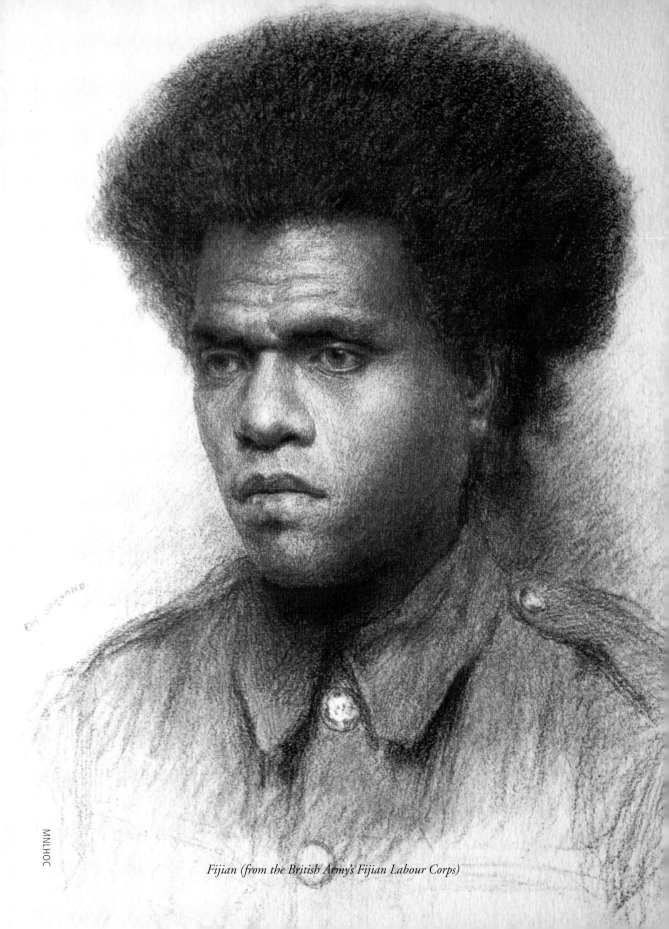

Fijian (from the British Army's Fijian Labour Corps)

MNLHOC

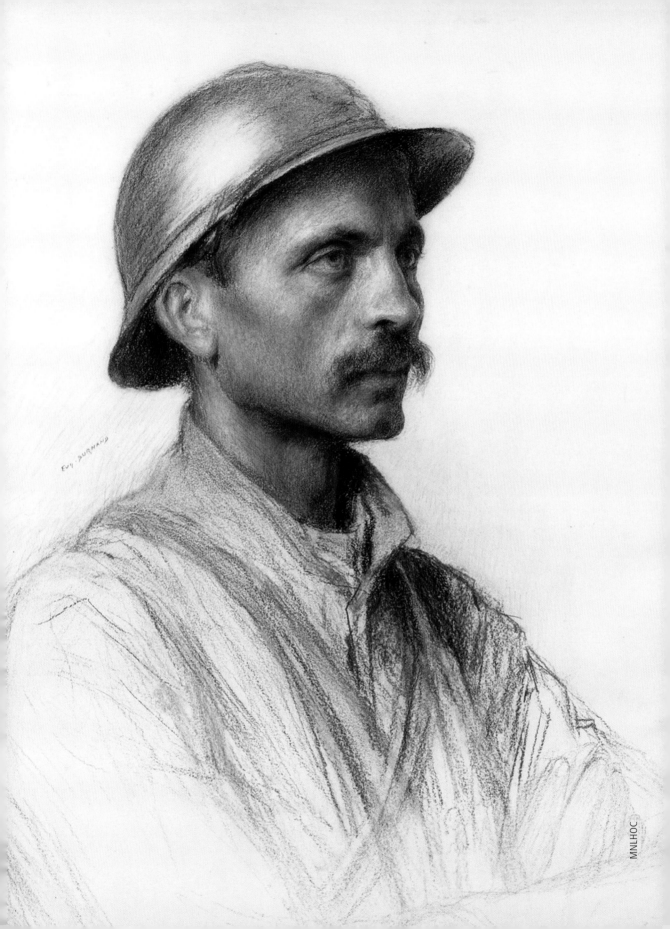

UNKNOWN SOLDIER

This soldier is one of the few without a name in Burnand's series of portraits. His nephew Robert, who wrote the commentaries, tells us he fought in Macedonia, where conditions were particularly harsh, and that he returned home with a fever. I was moved to write a poem about him, for the 2014 project "Letter to an unknown soldier". I hope it speaks for itself.

LETTER TO AN UNKNOWN SOLDIER

I saw your picture
in an old book
you did not have a name

a pastel portrait
done by a Swiss artist
among a hundred others.

Your face has haunted me
a suffering face
gaunt, hollow cheeks, sunken eyes
sick with a slow fever
brought back from the east

You fought in Macedonia
conditions were harsh
trenches cut from the very rock
years spent in tents
under a blazing pitiless sun
little water

A slow fever burned away,
sapping your strength
you fought on bravely
holding the line
a Frenchman, with the Allies
you won through in the end.

But did you survive that war
"La Guerre des Nations"
The Great War
where so many lost their lives?

You sat for your portrait
knee to knee
with an artist of great humanity
he captured your spirit
for eternity.

Shirley Darlington
June 2014

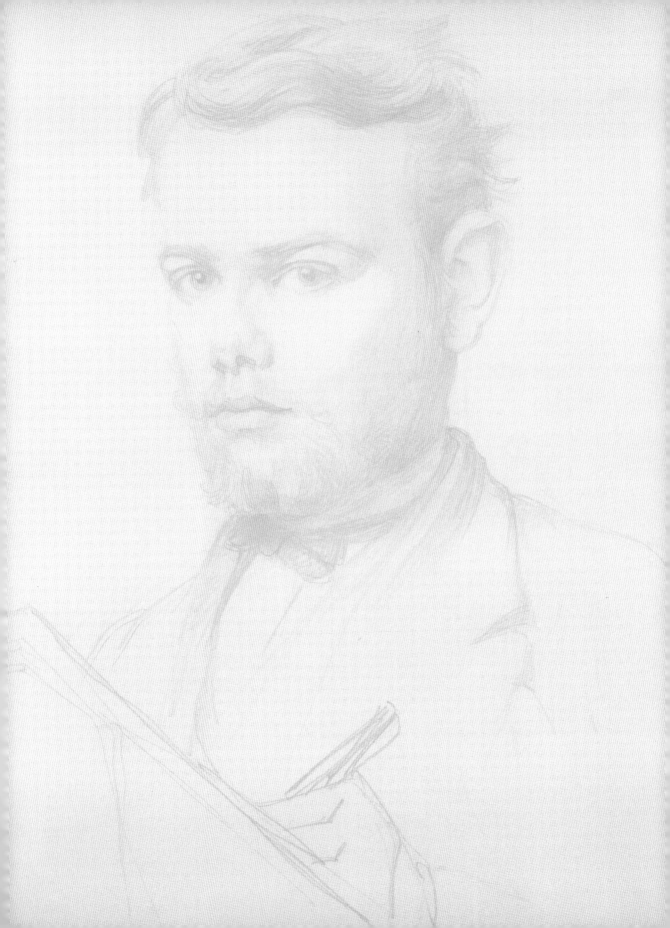

PART TWO

SWITZERLAND

IN THE SUMMER of 2014 Doug and I met up at Geneva airport to do some research on the Burnand family and look at the archive held in Lausanne University. Doug, as usual, had travelled in his motorhome, while I flew in from Gatwick. Finding each other was a little fraught as he could only drive by the drop-off point, ("Kiss and Fly"), and of course it was not where I arrived – so we spent some comical minutes trying to spot each other at some distance, exclaiming "Where are you? I am here!" Eventually I solved the problem by going back into the airport and coming out of Departures. He told me I was a nightmare, and I tried to retain my cool and dignity without success, feeling somewhat aggrieved. Of course it is always the woman's fault…

But off we drove towards Moudon, Burnand's birthplace, and peace was restored. I had managed to book myself in to an interesting bed and breakfast owned by a Dutch woman and her tall American husband. It was in a charming neighbouring village called Lucens. The couple had lovingly restored an old cheese factory, a massive stone building in the old part of the town. My room was cool and comfortable, in the basement. Breakfast included delicious homemade bread and preserves, and scrambled eggs to keep me going all day. Apart from myself there were several German workers staying, and very noisily watching the football World Cup: of course their team were victorious and they had headaches next morning.

That first evening the sky drew darker as clouds gathered ominously, and we had the bizarre experience of eating an excellent Chinese meal in the village bar in the middle of a torrential thunderstorm with giant hailstones bouncing on the roof above our heads. Needless to say we did not have an

RIGHT: *Burnand family home at Sépey (author's photo)*

umbrella, and Doug heroically went back to the motorhome to fetch one, so that I did not get soaked to the skin. Perhaps he felt the need to atone for calling me a nightmare.

The next morning we were to visit the town of Moudon, and of course the museum housing Eugène Burnand's paintings. We drove up the Avenue Eugène Burnand, feeling rather grand. The town has an attractive old centre and a lovely old church, which was a stopping point on the pilgrimage route to Compostela, and has a wooden sculpture commemorating the pilgrims. We went to the Information office, Moudon Tourisme, and Doug asked for permission to photograph some of the pictures in the museum. He was welcomed with open arms by Carole, the director, and ended up being commissioned to make a photographic record for the town's website. I was introduced as the colleague who had done the majority of the translations of the French text by Robert Burnand into English, and Carole seemed impressed. But I think she was more interested in how useful Doug might be, and of course was charmed by him.

The museum was not open until the afternoon so we set off to the nearby hamlet of Sépey where the Burnand family home was located. To reach it we had to cross the railway, which apparently the Burnands had used to reach their house in the summer each year, walking up the half mile or so from the station of Bressonnaz. This was now very rural Swiss countryside as I had imagined it – rolling hillsides, little narrow lanes with arrows indicating walking trails, and lots of cows. We parked just outside the small hamlet and walked towards the fine country house, dating from the 1600s, which I recognised from pictures.

Farm building with frieze at Sépey by Eugène Burnand (author's photo)

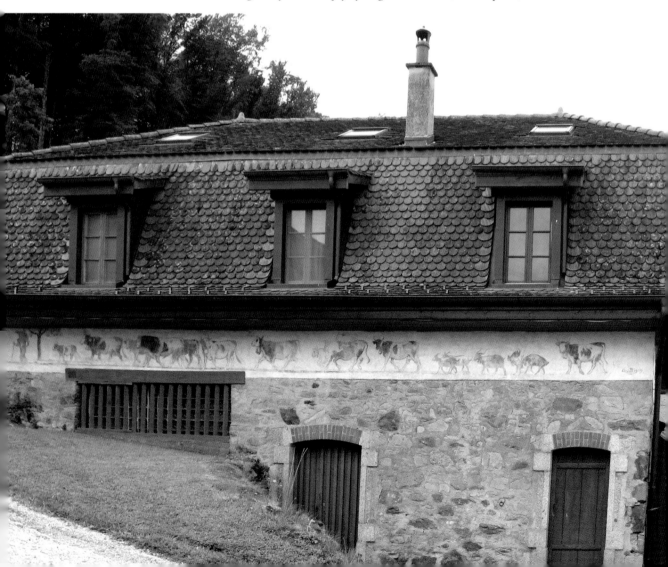

It was a delightful place, secluded and tranquil with many fine trees and lovely gardens. The house is still lived in by family members, so we tried to be discreet though consumed with curiosity. There are farm buildings nearby in a lane and it was intriguing to see old barns and cows so often painted by the artist. One building still has a frieze, under the roofline, of brown and white cows being led by the farmer, painted by Burnand, charming and still in good condition.

His atelier or studio where he painted is near the house, and it was there that many works were discovered after his death. There is a lovely old fountain just before the house (*see below*), with the head of an old man spouting water, which also features in Burnand's drawings and paintings.

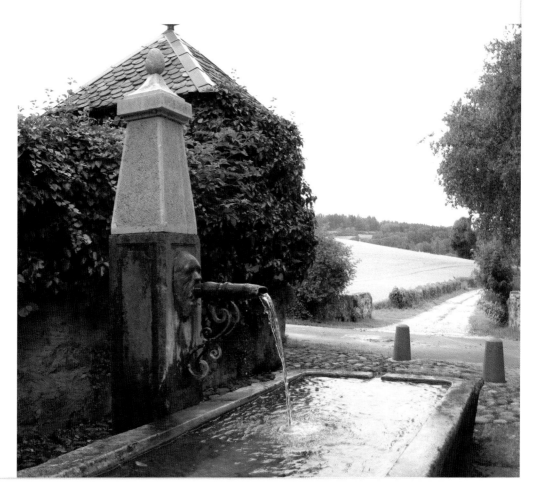

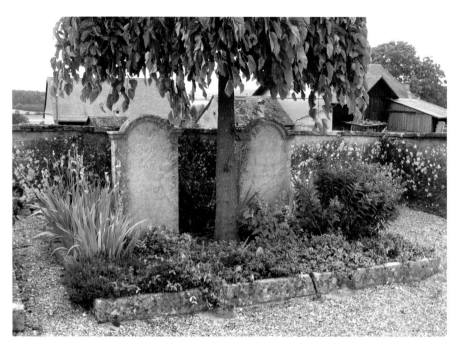

Burnand Family graves at Vulliens and Vulliens church (author's photos)

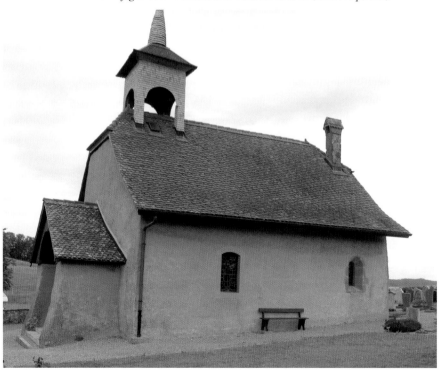

After wandering around happily for some time, we drove on along the lane to the nearby village of Vulliens, which has a tiny church and beautiful churchyard where the artist and his wife Julia are buried, along with several members of the family. The two graves of Eugène and Julia are next to each other, with a shapely tree growing between the two and shading each. The stone headstones have simple inscriptions: on Eugène's is written "*Je sais en qui j'ai cru*": "I know in whom I have believed" and on Julia's "*Alors nous verrons face à face*": " Then we shall see face to face", a testimony to their faith. The churchyard looks across the valley to the hills beyond.

I asked if we could go into the church, and Doug said it had been locked on a previous visit, but when we tried the door it was open. It was very plain, a Lutheran church, in keeping with Burnand's Protestant faith. There I made a small discovery of my own: there were some stained glass windows. I said to Doug, "these remind me of Burnand's style, yet not quite the same…" I looked closely and discovered they were signed by David Burnand, one of the artist's twin sons. His twin brother Daniel was also a fine artist, who died in the Spanish influenza epidemic in the winter of 1918–19. Both are also buried in the churchyard.

We took photographs and emerged again into the sunshine. I felt very moved and privileged to have been close to the artist in quite an intimate way. "Thank you for sharing this with me" I murmured, and we gripped hands wordlessly. That meant a lot to me, in our shared quest.

<center>⨎⫸⫷⨎</center>

That afternoon we drove up the steep narrow winding street of Moudon up to a flat square at the top. We were greeted by a fountain filled with red geraniums and two huge old stone buildings; one housed the museum of

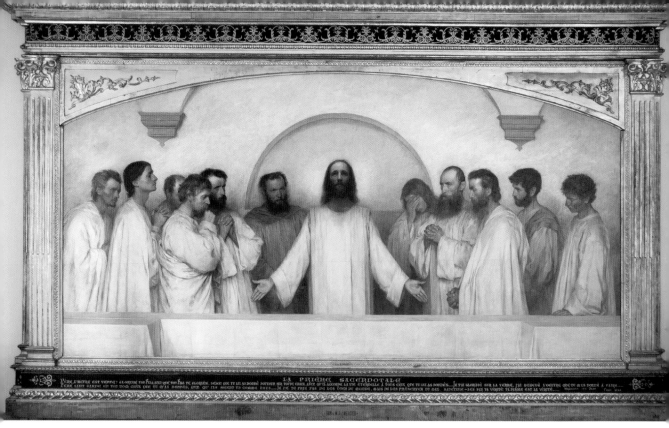

The Sacerdotal Prayer 1900–1918, Musée Eugène Burnand, Moudon

Moudon, the other the Musée Eugène Burnand. There was a glorious view over the rooftops to the surrounding wooded hills and fields, with cowbells gently tinkling, birdsong and a stream running down to the town's river. I breathed in the idyllic scene. Then we climbed the stone steps up to the gallery in which Eugène's paintings were hung.

There were several light and spacious rooms, and I was struck immediately by the immense size of some of his major works hanging there. These were mainly oil paintings, for example his version of Christ praying for his disciples, just before his betrayal, which has Christ standing amid the disciples, repeating his prayer of consecration to God's will. This painting is known as "The Sacerdotal Prayer", and fills a whole wall, in an elaborate gold frame. It is awe-inspiring. The models for the disciples are people

Burnand knew, and their names are listed there. They are wearing simple white robes, rather than anachronistic supposed middle-eastern dress of the time. This painting was reproduced in a German book and found its way to America, where it is still in demand in reproduction.

Another painting which caught my eye was a most beautiful depiction of the local landscape with its hills and valleys at harvest time, with two young women in the foreground gleaning wheat. The picture is full of glowing autumnal light, and clearly influenced by Millet's treatment of the same theme, though the young gleaners are in more upright pose, one standing, the other kneeling as she binds her sheaf, and of more modern appearance, wearing Swiss traditional dress – probably local girls he knew. A heavily laden haycart is in the background behind them. It is a tender picture of the countryside he loved and its inhabitants.

The other huge and striking picture, another oil painting, perhaps one of his best known, is "The Bull in the Alps" in which Burnand shows his prowess as a painter of animals. His close observation of the powerful beast makes it come alive, as it stands on a promontory bellowing into the mountain valley below. And another, "La Ferme Suisse", of cows drinking outside their stable from a trough, shows his eye for the rustic vernacular scene, down to the detail of the cow's bell lying sideways along the edge of the trough as it lowers its head to drink, and the ripple of water in the trough, all lovingly painted. This painting won a gold medal in the Paris universal exhibition of 1889. He had raised the status of genre painting by his fine naturalistic skill, to that formerly held by history painting.

The depiction of the local fire brigade rushing to put out a fire in their horse-drawn fire engine "La Pompe à feu" is a lively image of movement and urgency, with the locals, whips raised, spurring on the horses. This

picture is of historical and local interest, and shows Burnand as fully engaged with the rural life of his time, which he wished to preserve for posterity.

He painted shepherds, animals being driven down to their pasture, horses by the sea in the Camargue, and many scenes of rural buildings in their setting with surrounding trees, often pine trees in the south of France, whose shapes fascinated him.

There were also portraits: a self-portrait as a young man, local countrymen and women, and a lovely sensitive portrait of his wife Julia. Three of the

La Ferme Suisse, Swiss Farm 1882, Moudon

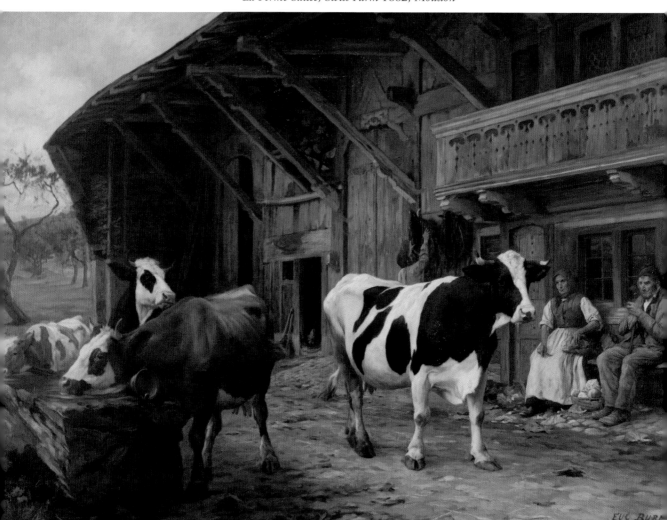

famous set of First World War pastels are hanging there, one of a zouave, or North African soldier, another striking one of a black American soldier, and the third a Serbian chaplain. It is not known why these are kept at Moudon rather than with the others in the Musée de la Légion d'honneur in Paris, but perhaps it was at the artist's wish, or that of his family. What is known is that there was a serious fire in his atelier in Paris shortly before he died, and that the pastel portraits narrowly escaped being burned. Burnand says all except three or four were undamaged, because they were under glass. Some may have suffered smoke damage and needed cleaning, so perhaps that is why they are there.

I also spotted a smaller engraving of the first pastel portrait in the series, that of the Fantassin Desvignes, the ordinary French foot-soldier. It had some tiny writing in the corner, which I eventually deciphered and translated. It was in Burnand's own hand, and stated "I made this engraving for the Crété book of pastel portraits", in other words he had made the engraving himself, and was pleased with it! I had often wondered how the engravings were made for the 1922 book, and here was my answer. What an undertaking for a man of 70, in poor health. Of course it does not prove he made all one hundred himself, but perhaps he was setting the standard for the work. His correspondence with the publishers reveals he was very particular about the reproduction process, and asked for utmost care in removing the pastels from their frames and glass for the photographic process of photogravure, and the exact sizing of the pictures for the book.

Walking round the rooms of the gallery gave one the sense of meeting the artist in all his moods, with all his different interests, in the human, the spiritual, and the natural world, with his high regard for the history of his homeland and his wish to record and preserve it in art for posterity. The town of Moudon can be proud of how it has respected its famous artist

and made his work available for visitors to see. We were alone that day, which made it easy to look at the pictures in detail, but I wished they could be made available to a wider audience, and hoped that one day this might be possible.

Next day, a Sunday, dawned bright, warm and sunny, and we walked up to the top of the hill in the village of Lucens where there is an amazing fairytale castle with pointed towers and a drawbridge, apparently now owned by the locality and still used for weddings and other ceremonial events. This is where Doug had parked his motorhome for the night, and I envied him the spectacular views and setting, surrounded by forest and overlooking the valley below.

We had planned to visit the art gallery, Musée des Beaux Arts, in Lausanne, which we did, though the day was so beautiful my host at the B&B had suggested a drive along Lac Léman to admire the scenery too, and this was a very tempting prospect. We managed to find a space to park near the old central square in Lausanne, and made our way past the cathedral down to the art gallery, admiring the view over the rooftops to the lake and mountains beyond as we walked.

The gallery was meant to house several of Burnand's paintings, according to information we had gleaned from our reading. However, as with the Musée d'Orsay in Paris, when Doug went off to enquire where they were he was told none were currently on display, and some had been moved to other galleries. This was disappointing, but while Doug was upstairs looking I found several reproductions of the artist's work as postcards in the museum shop, which were works I had not seen before, so I was happy to be able to purchase these and inform Doug of my find. One was a different beautiful portrait of Julia Burnand, his wife, as a young woman, probably

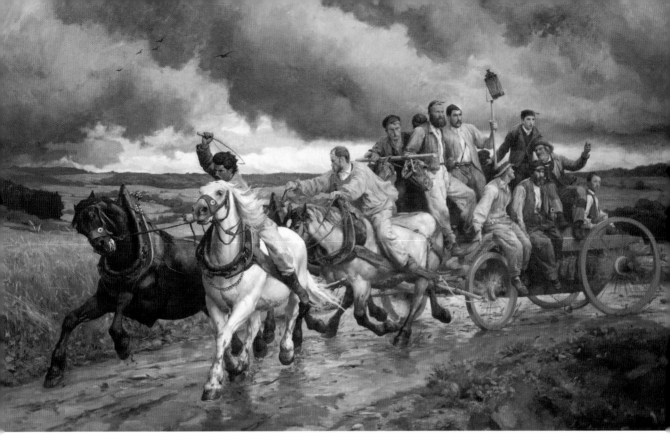

La Pompe à Feu, the village fire engine, 1879, Moudon

painted around the time of their marriage. It now sits on my mantelpiece at home. There was also a delightful sketch of his twin daughters, Rita and Mireille, as babies, which neither of us had seen before.

We felt we had earned a coffee and sat in the square, which was filled with a Sunday market, and watched the world go by in the sunshine. We discussed the Burnand family, which Doug had been researching, and had been in touch with Mireille's daughter Jocelyn, Burnand's granddaughter who now lives in Yorkshire and owns several important Burnand paintings. The card of the twins would certainly be given to her! Both twins had married English Quakers, and had subsequently lived in England.

There were eight surviving Burnand children, including two sets of twins,

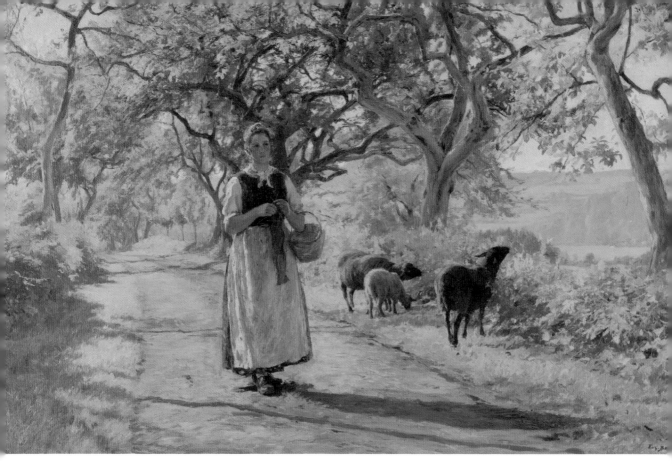

La Bergère (Sous les pommiers), shepherdess under the apple trees, 1889/1896, Moudon

which must have been quite a challenge for Julia as their mother, with an artist husband who loved to travel to paint and invariably took the whole family with him in a somewhat nomadic existence, while never losing his roots in his home in Switzerland. There is a lovely account of their summer visits to Sépey in Mireille's book, *The Swiss Family Burnand*. This was published in 1951 with illustrations by her daughter Jocelyn.

It was such a beautiful warm day we succumbed to temptation and drove off down the lake towards the high mountain peaks in the distance, following the lakeshore. The hillsides facing south were covered in vines, and the scenery delightful. We passed through Vévey, mentioned in Burnand's diaries as one of his favourite places, then on to Montreux, with its very

grand lakeside hotels painted gold and white, where the well-known film festival is held. Then we came upon the Château de Chillon, made famous by Byron, built out on the edge of the lake, its silhouetted towers the very image of a romantic idyll. I begged to stop and we walked down to the lake for a welcome ice cream and a touristy photo opportunity – but the setting of the castle deserves its reputation for spectacular beauty and I was suitably overwhelmed with delight.

We consulted the map and decided to drive on beside the lake, towards a pass through the mountains and another familiar name, the Château de Gruyère. At the end of the lake was a formidable range of high mountains like a solid wall, with the Dents du Midi raising their craggy jagged teeth at the centre of the view. We turned off at Aigle and the road twisted and

Chateau de Chillon (author's photo)

turned through terrifying hairpins towards the summit of the pass, with the view becoming ever more spectacular. I am glad to say the driver kept his eyes on the road. As we reached the top there was a plateau, filled with another Sunday market, where we stopped to buy food and local wine for our supper. It had been a very hot day and we noticed some towering billowy white clouds beginning to loom up behind the mountains.

We drove on to Gruyère, which has an attractive medieval castle perched on a hill at the top of the village, and stopped for a cooling glass of beer, which was very welcome. On arrival back at Lucens we started to prepare supper in the motorhome, as guests were leaving a wedding party in the castle. The clouds grew more ominous and rolled towards us across the valley, the sun disappeared and angry flashes of lightning forked down from the now black sky. Then the storm began in earnest, the temperature dropped, thunder crashed, giant hailstones and gusts of wind lashed the motorhome, nearly deafening us. The poor wedding guests were seen scurrying to their cars, drenched by the rain, umbrellas useless. The storm passed, the sun reappeared and we enjoyed our last supper together in peace, appreciating the delicious local wine. I could have stayed all night gazing at the view, dripping trees, and sunlight making everything sparkle, but "Come on, I'll walk you home now" said Doug, so I reluctantly agreed to leave that special place and went down the hill to my solitary B&B for the night.

<p style="text-align:center">⊛⊷¦3⊷¦∗⊷¦3⊷¦⊛</p>

Our next mission was to visit the Burnand archive at the University of Lausanne library. We met the librarian and were taken to view the archive, located in a basement room and consisting of many box files. We had to sign identity documents and promise not to reproduce anything without permission from the University. The boxes were labelled and had been

sorted and catalogued, apart from another whole large section of family papers as yet un-catalogued. Our librarian gave us a list of the catalogued boxes, to see what subjects were of most interest to us. My eyes lit upon the word "Journaux" and I asked to see these. The boxes were brought up for us and we opened them with some excitement. They did indeed contain Eugène Burnand's own diaries, mostly of his early life. They were small neat leather bound volumes written closely in his own handwriting, and as I held one in my hands with wonder, it fell open at the same date as the very day we were there, July 7th, 2014 but for 1877! As I read, I realised it marked a very special day: he was expecting the arrival at Sépey of his wife-to-be Julia, and he expresses his excitement and delight in the knowledge of their love for each other, as an unexpected blessing. The page also stated "*Fin de la Première Période*" – end of the first part of his life as recorded in the diaries. The following page was headed "*Suite-La Seconde Période-31st July Nos Fiancailles!*" (Our engagement). I felt a shiver of kinship with the man, moving from youth to being a man with responsibilities. He and

Le lac Léman, au premier printemps, Lake Geneva, early spring, 1893 (Hotel Victoria, Glion-sur-Montreux)

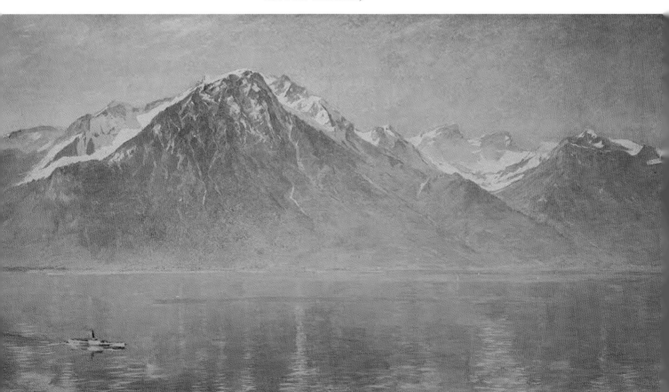

Julia were married in July the following year, 1878, in Versailles. They were happily married until their deaths four weeks apart in 1921.

The boyhood diaries contained many small drawings and anecdotes, and I would have loved to have had more time to study them in detail. I asked the librarian whether there were any of a later date, and he thought maybe those might have been elsewhere, perhaps used by René Burnand for the biography, or Professor Kaenel of the University for his work on Burnand. I also asked about the *Liber Veritatis*, Burnand's account of his artistic work, but the librarian said he thought that was with the family, and not part of the archive. His war diary was at this time thought to be lost. I was particularly interested in this because I wanted to know how Robert Burnand had written the commentaries on the First World War pastel portraits, and whether Eugène Burnand himself had had any hand in this. The librarian did not have any further information on this matter.

At this point I sadly had to leave to return home to England, leaving Doug to do further exploration of the archive and family papers. He drove me to the airport in Geneva, this time to the "Kiss and Fly" of Departures. We did have time for a quick hug, and then I flew back home.

When I arrived home I put my Swiss photos on my computer and gazed at the treasure trove. "These would make good illustrations for a book", I thought to myself. Doug had stayed on in Switzerland, to do more research in the archive, and to take professional photos of all the Burnand pictures in the Moudon Museum, followed by some sightseeing around the country. On his last day there he had been invited for lunch at the family home at Sépey, and wrote to me in some excitement. He had asked

RIGHT: *Julia Burnand, portrait by Eugène Burnand, (1889/1892) private collection*

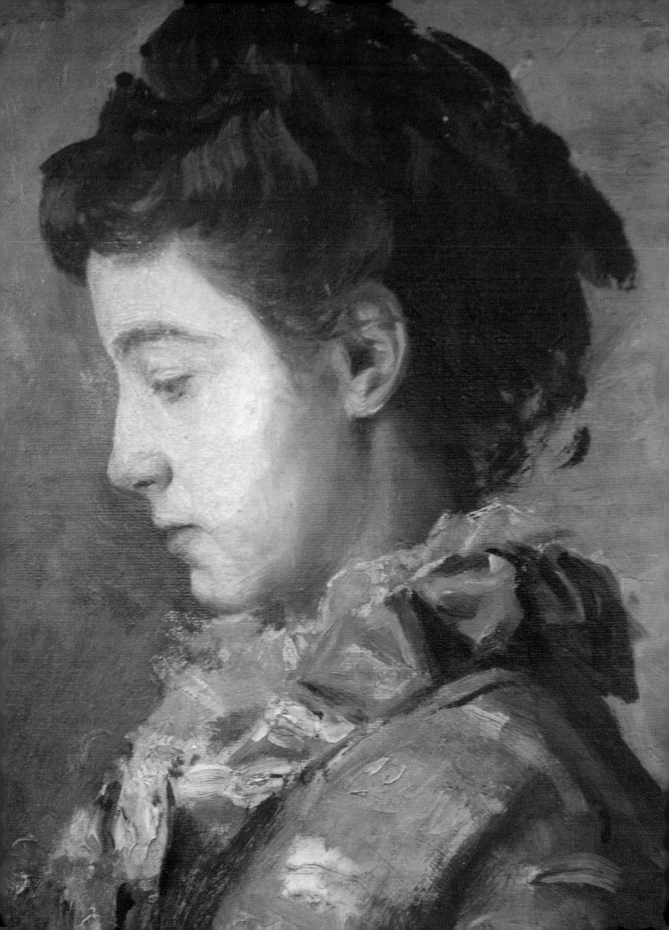

casually if they knew where the *Liber Veritatis* was, and Michel, Burnand's grandson, said "It's here!" so Doug asked "Could I see it?"

The heavy, dusty old book was brought out; he was able to see and photograph important pages from that document, including sections about the pastel portraits, which he then sent to me. Unfortunately the writing was badly faded and mostly indecipherable, but I recognised sections quoted in his son René's biography of the artist.

Also on the wall of the house was the original of Burnand's beautiful portrait of his wife Julia, of which I had bought the postcard. It had been given to Michel and his wife as a wedding present. Doug was also able to photograph this oil painting, which has a slightly Impressionistic quality with loose brushwork, for his English website.

I was now flooded by material sent to me by email, and thought, I must write something in English about all this and make a record, because the art is of such fine quality it deserves a wider audience, and none of the writing about Burnand as an artist is in English. And so I started to write.

<div align="center">⊰⊱⊰⊱⊰⊱</div>

Several months later I was in the English Lake District for Easter, staying at my old stone cottage there. I was out walking when a text message pinged into my mobile phone. "Look at the Daily Telegraph editorial for Easter Saturday. It features Burnand's painting of the Disciples Peter and John running to the tomb on the morning of the resurrection!" From Doug, of course. Fortunately my neighbours were *Telegraph* readers and kindly saved the piece for me. The headline stated, "Despite everything, the Easter sun still rises" and there followed a detailed description of the

great painting of the Disciples, which was the subject of a special Easter exhibition at the Musée d'Orsay in Paris. The writer of the Comment column sympathetically draws attention to the skill of the artist in depicting the two men running, anxiously, to the tomb, in the early morning light of that first Easter day. The piece was accompanied by a reproduction of the picture itself – the very one we had been so keen to see in Paris, and had been so disappointed to learn that it was not then on display.

This is a sign, I thought. Burnand's most famous work has found its way into the British consciousness. The time has come to bring this artist to public attention. So here is his story, and ours. I hope and trust it will lead others to explore the artist's work for themselves, and to enjoy and appreciate the wonderful treasures we found.

The Disciples Peter and John running to the tomb on the morning of the Resurrection,
1898, Paris, Musée d'Orsay

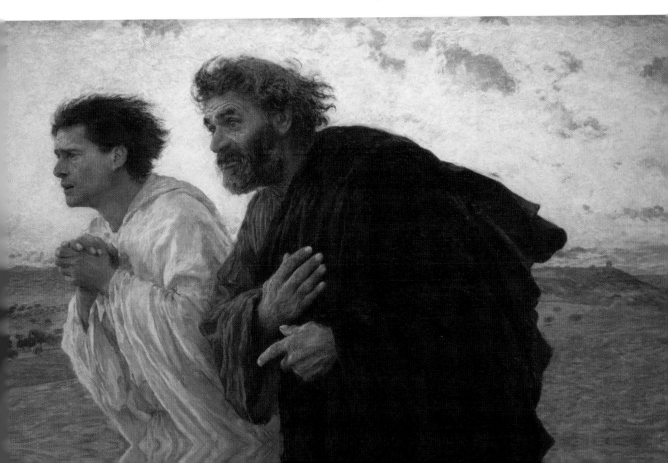

LOST AND FOUND – A Parisian Coda

AFTER, AS I thought, completing this book, we were contacted by a French art expert with an amazing story. One of Eugène Burnand's earliest large paintings, long thought to be lost, had re-surfaced in Paris. It had come into his hands through a close friend, a sculptor, who had in turn acquired it from its owner via a deceased French painter, Emile Mangiapan (1925–2007). The latter claimed to have bought it from a French peasant family in southwest France in 1944.

This huge oil painting (140 × 210 cm) was called "La Fournée dans un village des montagnes" and is listed in Burnand's *Liber Veritatis*, as reported in his son's bibliography and catalogue of paintings, with the additional information that it was of the bread oven in the village of Marécottes sur Salvan (which is near Martigny). It also had the intriguing information that it was sold for the national lottery for the great exhibition of 1878 in Paris.

Our French contact in Paris was clearly very excited by this find, and wanted to share the information. He explained that the painting had been found in a poor condition, from having been stored in a barn for many years. There was no record of the people who had won the painting in the lottery, as they were anonymous, but the story of what the lottery was for, is quite extraordinary. Burnand had painted his huge canvas especially for the 1878 exhibition, which had different pavilions for different countries, and this picture was considered by the art critics of the day as the best in the Swiss pavilion, and one of most important of the whole exhibition. The editor of the illustrated magazine *L'Art* had an engraving made of the painting, before it was taken away, and this was the only record of it, made by Fortuné Méaulle in 1878.

At the time of the exhibition the French sculptor Auguste Bartholdi was working on the Statue of Liberty, which was to be a gift from France to the United States of America to commemorate the centenary of its independence, but the money ran out and he asked the French state to organise a lottery to raise funds to enable him to complete the massive sculpture (which now stands in New York harbour). The head of the statue was displayed on the Champs de Mars at the entrance to the 1878 exhibition.

Statue of Liberty Paris 1878

A commission chose the best pictures in the exhibition as the lottery prizes, and that is how Burnand's painting of La Fournée came to be chosen. The French government paid him 3,000 gold francs for it – a huge sum of money for a young painter just starting out on his career. The lottery was a great success and sold twelve million tickets: the money raised enabled the sculptor to complete his work, so indirectly Eugène Burnand helped to finance the Statue of Liberty!

This meant another trip to Paris. Doug and I drove to Ashford and hopped on Eurostar for a day trip to see the re-discovered painting. We had an exciting day. Our host met us near his friend's workshop, which was situated in an old water tower in the grounds of an extensive hospital complex, securely guarded. We did not know quite what to expect, given that we had been told the painting had been in a poor condition when found. There a drama unfolded: as we entered the workshop, we looked upwards, and there we saw hanging, covered in a white sheet, the painting which had been "lost" for 137 years. The white sheet was slowly removed, unveiling the spectacular painting. It was a very emotional moment. I could not speak. The colours were dazzlingly bright, especially the white apron of the central figure, who was a statuesque woman carrying a basket of newly baked bread, fresh from the oven, smoke billowing behind her. She held the hand of a small boy, who was clutching a large loaf of bread, and staring out directly at us the viewers in a challenging way. The villagers sat around waiting for their bread to bake, against a backdrop of an old Swiss mountain village. One could just pick out a chapel, and a school, with children and their teacher outside.

The painting was clearly a very ambitious one for such a young artist – he was 27 when it was painted, and it was signed and dated, 1878. Our guide explained the process of cleaning and restoration he had undertaken, and

A bread oven as depicted on a Marécottes postcard, 1948

certainly the colours looked as bright and fresh as when it had first been painted. He told us it had suffered some damage in a lower section of the ground, which had been reconstructed using the engraving as a template.

One of the discoveries he was most excited about was the fact that during cleaning he had found a tiny inscription amongst some red flowers, containing the name of the artist's wife, Julia. This was unprecedented in Burnand's work. But it had been painted in the year of their engagement, 1877, whilst on a walking holiday to the area, and completed in 1878, the year of their marriage, so this hidden expression of his intense love for her could be easily understood. Whether she knew about this dedication, we will never know.

La Fournée dans un village des montagnes, 1878 – restored painting

Le Paysan, 1894, Moudon

POSTSCRIPT

EUGENE BURNAND was famous in his lifetime as an illustrator of books. He illustrated Frédéric Mistral's provencal poem "Mireille" in 1884. He greatly admired Mistral, who became a close friend, even calling one of his twin daughters Mireille. She moved to England and subsequently wrote a delightful account of their family childhood in Sépey, near Moudon, Vaud, entitled "The Swiss Family Burnand", published in 1951. The illustrations for that book were provided by her daughter Jocelyn, who is herself an artist and has inherited the family talent. I had the pleasure of meeting Jocelyn at her home in Yorkshire in November 2015. She told me that Eugène had a positive regard for the French Impressionist painters, who were his contemporaries, and had taken her mother Mireille to meet Monet. She also related that in 1994 there had been a large Burnand family reunion in Sépey to celebrate the centenary of a well-known picture by the artist, of a farmer leading his two cattle along a farm track. To ensure the artistic genes were still operating in Burnand's descendants, all the family, children included, had to produce a picture, and these were displayed and judged. Jocelyn herself was acclaimed as the winner, since she had the clever idea of repeating Burnand's painting, but with the addition of many lively calves gambolling around, the progeny of the original cows!

Burnand also illustrated Alphonse Daudet's "Contes", and "François le Champi" by Georges Sand, in 1888. He provided illustrations for Bunyan's "A Pilgrim's Progress", but these were never published in book form. They were sold separately to museums or given away to friends. His most popular work was an illustrated set of "Les Paraboles", the biblical Parables, published in 1908 in Paris, and translated into German and English editions. These were widely used as a teaching resource, and were also popular in America.

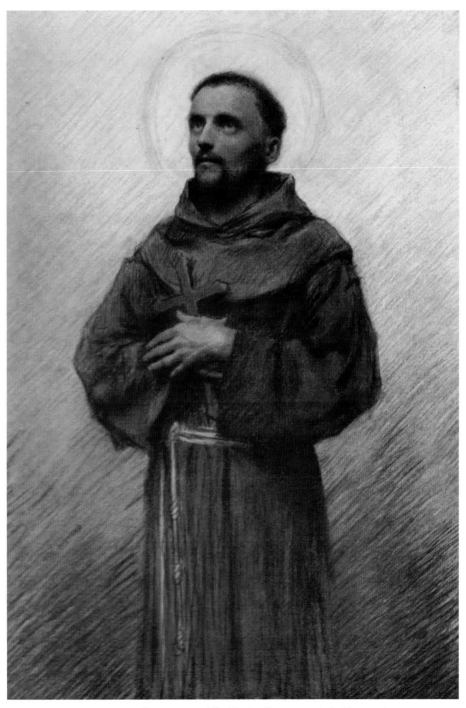

St Francis of Assisi as modelled by Ruffino, portrait by Burnand

He painted a series of stained glass windows of the Sermon on the Mount for a Swiss church at Hertzogenbuchsee, which were reproduced in book form in 1914. He was also commissioned to illustrate Swiss banknotes, and a famous poster with an alpine scene "Dans les hauts pâturages" for the Swiss company Nestlé.

A poster for Nestlé – Dans les hauts pâturages

In 1913 he travelled to Assisi to realise a long held dream in order to illustrate the "Fioretti", or "Little Flowers of Saint Francis". These illustrated stories of the life of the Saint were commissioned by JM Dent and Sons and published by them in London in 1919.

His diary records the delight of his arrival at last with his family for two stays in Assisi, in the spring and autumn of 1913. He recounts his realisation that there was still something of the spirit of Saint Francis floating in the air of Assisi, to which even modern day pilgrims are susceptible. He

Burnand won a commission for the 1000 franc and 500 franc notes in 1908.
These remained in circulation for many years.

Drawing for 500 franc banknote by Burnand, Moudon

describes walking around the town looking for a suitable model for his conception of Saint Francis, and finding a local shepherd who fitted the role. He recounts with some humour how he dressed the young man in a Franciscan robe, and as they walked about finding suitable locations for the portraits, Ruffino would offer confession to the young ladies along the route. He wanted to portray Francis as a real human being, as he felt his image had become too sentimentalised in previous depictions.

We followed in Burnand's footsteps, Doug and I, in the early hot days of July 2015. We were able to visit the hermitage, Eremo delle Carceri, in the woods on the side of Mount Subasio, where Francis and his earliest companion monks had a retreat. The beautiful Holm oak trees, with their gnarled trunks, painted by Burnand are still there, setting the scene where the Saint preached to the birds, and the birdsong is still there too – a wonderfully peaceful and atmospheric place. The house where Burnand and family stayed can be identified from his diary description, with its terrace leading off their rooms, overlooking the superb view over the whole plain of Umbria.

This project, in which Eugène Burnand could express his deeply felt spirituality, was interrupted by the outbreak of war in August 1914. He was working on the Fioretti just as war was declared, and had to leave his Paris studio to return to his family in Switzerland. Confined there by the war, he found another outlet, beginning in 1917 the remarkable series of pastel portraits which were the culmination of his life's work in the years of the Great War, until his death on February 4th, 1921. It may be that the esteem in which he was held at that time will be rekindled by re-appraisal one hundred years on, and that he will once again receive the richly deserved appreciation of generations yet to come.

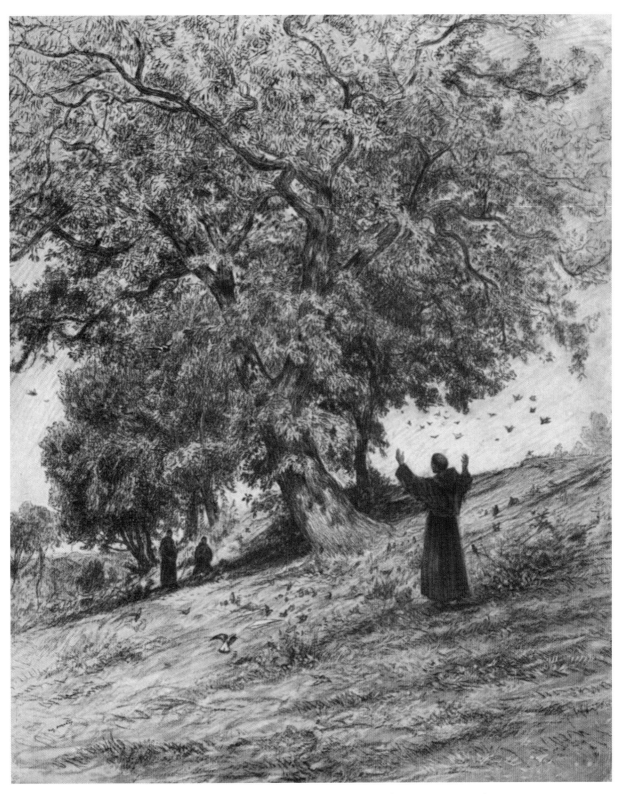

Saint Francis preaching to the birds, from the Fioretti, Little Flowers of St. Francis, painted in Assisi in 1913, published by JM Dent and Sons, London 1919.

A NEW DISCOVERY

FOLLOWING THE RECENT discovery of Burnand's War Diary, which had been thought lost, I had been turning over in my mind the revelation that he had been asked to collaborate with the German authorities in order to accept their forcefully expressed request to visit German prisoners of war held in France, and to look into their grievances and report on their conditions. His "collaboration permanente" was sought, even demanded, and the pressure put on him to comply created great emotional turmoil for him.

I wondered whether this was connected to a mysterious picture I had seen at the Museum in Moudon, of a young woman reading a letter from a prisoner of war. The letter had a red cross visible on it, and in the background was a classical building emitting rays of light. The whole picture has a mysterious and disturbing visionary quality. I decided to investigate further, and found information in René Burnand's bibliography from Burnand's *Liber Veritatis*, in the 1926 book about Eugène. The picture, entitled "La Liseuse", the Woman Reading, was commissioned by the firm of chocolate makers Peter, Cailler, Kohler for the International Committee of the Red Cross, to accompany gifts of chocolate sent to prisoners of war. It must have been done in 1917, the very year Burnand had his crisis of conscience about refusing the German request to visit their prisoners in France.

This would explain the visionary quality of the painting, with its image of rays of light emanating from the building, which I discovered was the

(The images on pages 113 and 114 are all contemporary chocolate wrappers)

Musée Rath in Geneva, the first fine art gallery to be purpose built as such in Switzerland, and one of the earliest in Europe. The building was taken over from 1916–1919 by the agency of the International Committee of the Red Cross as its headquarters for the welfare of prisoners and their

Musée Rath, Geneva

families, so they could maintain contact. Cards were included with the chocolate sent to prisoners, bearing the moving illustration by Burnand, showing the concern of family members and their appreciation of the letters sent by the good offices of the Red Cross.

The chocolate firm concerned was formed by a merger of three companies, one established by a Swiss compatriot of Burnand, François Louis Cailler, his son in law Daniel Peter, who was from Moudon and went to the same school as Burnand, and Kohler. They were all from the Vaud region, and teamed up with Nestlé, based in Vévey. They invented the famous Swiss milk chocolate, using Nestlé's condensed milk, and all the firms still exist, becoming world famous.

The Rath Museum is still a flourishing art galley in central Geneva. The equestrian statue in the picture near the museum is of Guillaume-Henri Dufour, by Alfred Lauz, 1884. Dufour was a renowned Swiss General, topographer and professor of mathematics. The highest mountain in Switzerland is named after him, the Dufourspitze. He presided over the First Geneva Convention, which established the agency for the welfare of prisoners of the International Committee of the Red Cross in 1863. This agency was awarded the Nobel Peace prize in 1917.

The original picture, "La Liseuse", with its powerful and moving symbolism of light conquering darkness, which must have been inspired by Vermeer's famous picture of the Woman in Blue reading a letter, hangs in the Musée Eugène Burnand in Moudon.

RIGHT: *"La liseuse" – young woman reading a letter from a prisoner, 1917*

A PORTRAIT OF THE ARTIST

EUGENE BURNAND BELONGED to no particular school, group or named style of artists. He was fiercely independent, and determined to plough his own furrow. His own favourite artists were the Tuscan Italian Fra Angelico, whose works he first admired in Florence in the Convent of San Marco, and the Dutch master, Rembrandt. Both these great artists had the gift of portraying what he would call "soul" in their paintings. In the Swiss countryside around him, and in his fellow human beings, he saw the hand of his Creator at work, and he aspired as an artist to follow this example all his life.

Switzerland was, and is, a relatively small country, and for anyone wanting to follow an artistic career it was necessary in the late nineteenth and early twentieth centuries to go to Paris, then the flourishing centre of the art world. But even during his artistic training Burnand stayed close to his own countrymen in his student fellowship. He developed a dual loyalty, to the country of his birth, and to France whose language he spoke and whose culture he admired. Though he travelled widely in his career, he moved often between France, Italy and Switzerland, probably spending the majority of his working life in France. The French artists Corot, Millet and Courbet were strong influences, and he took a friendly interest in the work of the French Impressionists who were his contemporaries. Like them he often painted "en plein air", and took for his subjects scenes of everyday life that surrounded him: the mountain scenery, rural life with its farms and animals, the trees, fields and pastures. He was particularly drawn to the quality of the light in southern France, and in Italy, as were so many painters.

RIGHT: *Le Faucheur, 1886, Moudon*

119

Burnand had a very wide repertoire as an artist, from small line drawings and sketches, caricatures, portraits and local scenes to huge oil paintings and panoramas. He joined in an enterprise with fellow Swiss artists to paint a panorama of the Bernese Alps, which at 115 metres long and 18 metres high was thought at that time (1889–92) to be the largest painting in the world, and needed scaffolding to be completed. It travelled to exhibitions around the world, including Paris, Geneva, Antwerp, and Chicago, until it was completely destroyed by a hurricane, or violent storm, in Dublin in 1903. Another painting of his, *Le Labour dans le Jorat* (1915), *Ploughing in the Jorat*, was also destroyed by fire in January 1916, and he repainted it in that same year – now in the museum in Moudon. And a serious fire in his atelier in Paris nearly destroyed his precious First World War pastel portraits. He joked that he must hold the world record for an artist who had his works destroyed by fire or storm!

A loving family man, Burnand always had his family around him, wherever he happened to be living and working at the time. He had many mouths to feed, and he was not rich, so he had to find ways of selling his work to make ends meet. He accepted many commissions for illustrating books, and other commissions which might be seen to be of a commercial nature; he felt that perhaps other artists, for example his fellow Swiss artist Hodler, tended to sneer at him for this reason. He had to wait seven years to marry his sweetheart Julia, until both sets of parents were convinced he was able to support a wife and family. It is therefore understandable that he was always very prudent over money matters, and indeed did sell paintings well, throughout his life. When his financial circumstances grew more secure he was able to indulge his wish to concentrate on religious painting, but

Burnand's drawing of his daughter Mireille, 1901

MIREILLE 1901.

his Swiss Protestant style was in general not very well received, especially in Catholic and secular France, and he soon realised that it was not a commercial success, much to his disappointment. His illustrations of the biblical Parables, however, in book form, did become popular in Germany, England and the United States of America.

In his private life he was a fun loving man, but in his role as respected artist with firm ideas he could be quite severe, and he had the misfortune to alienate some of his Swiss colleagues when his strictness over criteria for judging paintings suitable for Salon exhibitions was felt to have excluded them unfairly. As fashions in art changed, he was sensitive to the criticism

Photograph of the Burnand family

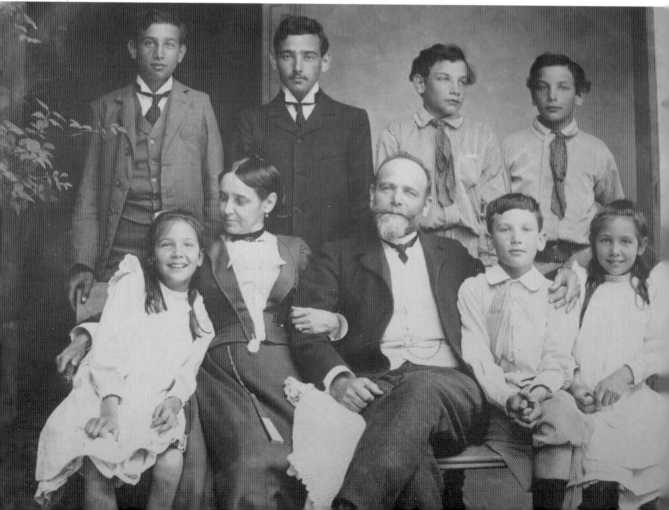

La Jeune Fille, 1914–17, Moudon

that his true-to-nature style had become what he called "vieux jeu" – old hat. In the art world, of course, fashions come and go, artists go out of favour and are rediscovered many years later. When Constable was painting, he could achieve little success in England until after his death, though in Paris he was acclaimed and emulated by later French artists. Van Gogh famously did not sell paintings in his lifetime, and now they sell for millions.

We are fortunate that Burnand's decision to make a series of portraits, first of his local people of the Vaud region, and then his war portraits, came to fruition in his lifetime. I have often wondered why his work did not become better known outside France and Switzerland, but I have realised that this often happens to artists from smaller countries outside the main art markets – for example I am aware as I travel that there were and are wonderful artists from countries such as Finland and the Czech Republic, who are never heard of in England. Remoteness from art centres has its price, and puts artists at a disadvantage for selling their work and becoming widely known. The Internet has become a wonderful resource for sharing information, not available in Burnand's day. And I feel that had he not died in 1921, with work still in progress on his portraits of the First World War Allies, he would have been around to help publicise them; they might have become better known and given him more enduring fame.

It is said that people who write biographies often become so absorbed by their subject, that they almost inhabit the personality they are describing. For me, writing this book has been a privilege, an enriching experience, and a labour of love. Although I feel I have only scratched the surface of all there is to know and appreciate about Eugène Burnand, if I have managed to capture just a little of the essence of this great man and his wonderful art, then I will be happy. To share it with others is a joy.

Shirley Darlington
Lewes, March 2016

Eugène Burnand, self portrait 1915, Moudon

EUGÈNE BURNAND par lui-même.

Hommage de les enfants au Musée

du vieux Moudon.— Septembre 1928.—

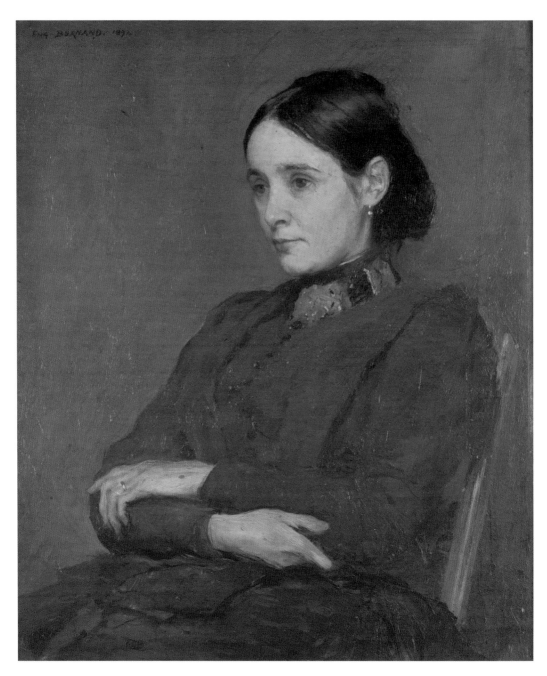

Portrait of Madame Julia Burnand, the artist's wife, 1892, Moudon

BIBLIOGRAPHY AND REFERENCES

Eugène Burnand, l'homme, l'artiste et son oeuvre, by René Burnand, Berger-Levrault, Paris and Lausanne, 1926

Les Alliés dans la Guerre des Nations, published by Crété, Paris, 1922, 100 pastel portraits by Eugène Burnand, photogravures, and commentary by Robert Burnand

Portraits de la Grande Guerre, les pastels de Eugène Burnand dans la Musée de la Légion d'honneur, Paris, commentary by Xavier Boniface, 2010, co-publication by the Legion of Honour Museum, ECPAD and Conseil Géneral de la Meuse, to commemorate the battle of Verdun

Eugène Burnand, La peinture d'après nature, 1850–1921, by Philippe Kaenel, Cabédita, Lausanne, 2006

The Swiss Family Burnand, by Mireille Burnand-Cooper, Eyre and Spottiswood, London 1951 (account of family childhood at Sépey, Switzerland, by Burnand's daughter Mireille, illustrated by his granddaughter Jocelyn Campbell)

Burnand family archive, Lausanne University (bibliothèque cantonal universitaire)

Eugène Burnand et la Première Guerre Mondiale: notes for a lecture by Frédérique Burnand, for the centenary of the start of the First World War, given at Moudon, August 2014

The World's War, Forgotten Soldiers of Empire, by David Olusoga, publ. Head of Zeus, 2014, paperback 2015. A powerful, well-researched account of the untold stories of the millions of Indian, African and Asian troops who fought in the Great War

Museum of the Legion of Honour, 2 rue de la légion d'honneur, Paris, next to the Musée d'Orsay, where the pastel portraits can be visited on www.legiondhonneur.fr

Musée Eugène Burnand, Rue du chateau 48, Moudon, Vaud, Switzerland has a large collection of Burnand's paintings www.eugene-burnand.ch Contact: office.tourisme@moudon.ch

Fondation du Musée Eugène Burnand, contact as above, organises events connected with the artist. President: Madame Frédérique Burnand, case postale 180, Ch. 1510 Moudon, Switzerland

Website in English for comprehensive information on the artist Eugène Burnand created by Doug Jenkinson, www.eugene-burnand.com